The Classical America Series in Art and Architecture

DOVER PUBLICATIONS, INC.

Greek and Roman Architecture in Classic Drawings by Hector d'Espouy
Monumental Classic Architecture in Great Britain and Ireland by Albert E. Richardson
The Secrets of Architectural Composition by Nathaniel C. Curtis

GUILD FOUNDATION PRESS

The Original Green: Unlocking the Mystery of True Sustainability by Stephen A. Mouzon

W. W. NORTON & CO.

The Golden City by Henry Hope Reed
The American Vignola by William R. Ware (also available as a Dover reprint)
The Library of Congress: Its Architecture and Decoration by Herbert Small
The New York Public Library: Its Architecture and Decoration by Henry Hope Reed
The Elements of Classical Architecture by George Gromort
The Architecture of the Classical Interior by Steven W. Semes
Classical Architecture for the Twenty-First Century: An Introduction to Design by J. François Gabriel
The United States Capitol: Its Architecture and Decoration by Henry Hope Reed
Arthur Brown Jr.: Progressive Classicist by Jeffrey T. Tillman
The Future of the Past: A Conservation Ethic for Architecture, Urbanism, and Historic Preservation by Steven W. Semes
Comparative Architectural Details: A Selection from Pencil Points 1932–1937, edited by Milton Wilfred Grenfell
The Theory of Mouldings by C. Howard Walker and Richard Sammons
Building Details by Frank M. Snyder, Introduction by Peter Pennoyer and Anne Walker
The Study of Architectural Design by John F. Harbeson, John Blatteau, and Sandra L. Tatman
Edwin Howland Blashfield: Master American Muralist, edited by Mina Rieur Weiner

PRINCETON ARCHITECTURAL PRESS

Antiquities of Athens by James Stuart and Nicholas Revett, Introduction by Frank Salmon
Basilique de Saint Pierre et Le Vaticane by Paul M. Letarouilly, Introduction by Ingrid Rowland

RIZZOLI

Bricks and Brownstone: The New York Row House 1783–1929 by Charles Lockwood

SAN MATEO COUNTY HISTORICAL ASSOCIATION

Carolands: Ernest Sanson, Achille Duchêne, Willis Polk by Michael Middleton Dwyer; produced by
 Charles Davey

STERLING PUBLISHING

Get Your House Right, Architectural Elements to Use & Avoid by Marianne Cusato & Ben Pentreath with
 Richard Sammons and Léon Krier

For a complete list of titles in the Classical America Series, visit www.classicist.org

INSTITUTE OF
CLASSICAL ARCHITECTURE
& CLASSICAL AMERICA

The Institute of Classical Architecture & Classical America (ICA&CA)
is dedicated to the classical tradition in architecture and the allied arts in the United States.
Inquiries about the ICA&CA mission and programs are welcome and should be addressed to:

The Institute of Classical Architecture & Classical America
www.classicist.org

SECRETS OF **GOOD DESIGN** FOR ARTISTS, ARTISANS & CRAFTERS

BURL N. OSBURN

DOVER PUBLICATIONS, INC.
MINEOLA, NEW YORK

IN ASSOCIATION WITH THE INSTITUTE OF CLASSICAL ARCHITECTURE & CLASSICAL AMERICA

Bibliographical Note

This Dover edition, first published in 2011, is an unabridged republication of *Constuctive Design,* originally published by Bruce Publishing Company, Milwaukee, in 1948.

Library of Congress Cataloging-in-Publication Data

Osburn, Burl N. (Burl Neff), 1896–1962.
 [Constructive design]
 Secrets of good design for artists, artisans and crafters / Burl N. Osburn. —Dover ed.
 p. cm.
 Originally published: Constructive design. Milwaukee : Bruce Pub. Co., 1948.
 Includes bibliographical references.
 ISBN-13: 978-0-486-48041-1 (pbk.)
 ISBN-10: 0-486-48041-0 (pbk.)
 1. Design. I. Title.

NK1510.O8 2011
745.4—dc22

2010040577

Manufactured in the United States by Courier Corporation
48041001
www.doverpublications.com

FOREWORD

THE philosophy which underlies these pages is best expressed in the author's own words: "Designing is a process of seeing the need, analysing the functions, knowing the materials, understanding the processes of forming, and in all these steps of developing sensitivity to beauty."

Here the author has set down in a minimum of space with a maximum of charm the basic facts for the student who would produce and for the layman who would appreciate and enjoy the principal materials and the forms which man shapes from them for his use.

One sees, almost at a glance, in these words and amplifying drawings the relation of thinking and meeting needs in the designer's act. One imagines the author saying to himself as he writes of metal, for instance: "I must give the main facts about metal as briefly as I can and illustrate some of them because the need is not only to state the facts clearly, but to make the whole page interesting, yes, as beautiful as I can. I wish I could bring to the reader some of the choice objects in metal I know about with their colors, their textures, and their forms; but since they are in different parts of the world and are of many ages, the best I can do is to say a few words about the materials and draw a few pictures of some of their beautiful forms hoping that these will serve as symbols of countless objects of beauty which man has made of metal." And on a single page, in fewer words than I have used here, he has described sheets of copper, brass, pewter, lead, aluminum, steel, and silver; he has given their colors, told how the metals may be worked, and has made drawings of four superior examples of design and craftsmanship in as many media.

This book, so well named, is primarily for teachers, designers, and craftsmen who will welcome it for its clear, condensed and practical directions; but it should make an even wider appeal to laymen because of its sound contribution to correct knowledge about materials and good taste in shaping them into useful forms. To the increasing number of people concerned with the arts of the book it will have a special appeal, for it is a rare instance in which the author, the calligrapher, and the illustrator are one and the same, and in each case Dr. Osburn's work is distinguished.

Allen Eaton

INTRODUCTION

This book is written especially for the teacher of industrial arts. It is based on the assumption that making things is not enough in itself, valuable as it may be. To bring the greatest returns the making should be preceded by planning. The power of thinking – planning – designing – is a necessary part of the learning process which may, like other skills, be taught and improved. The discerning teacher will note that the designing process follows the steps in reflective-thinking. A further assumption is made that the ability to design is not one possessed only by a pre-ordained class of persons who hold some mystic power not granted to other men, but that it is simply intelligence at work.

If the craftsman is to get the fullest measure of satisfaction and value from what he makes, he must also be its designer. If his job is badly designed his work is in vain, regardless of the skill employed in its making. The beginner must start with something simple and readily capable of solution. He must not expect to design in some medium whose nature and working processes he does not understand. Hence reading, observation, and direct experience must accompany each area studied. Problems are presented here so the learner must:

1. Complete an article by adding a suitable appendage, or other part,
2. Design something to match a given piece,
3. Correct balance, or improve order,
4. Correct style anachronisms,
5. Analyze the requirements of a problem, and draw up specifications,
6. Produce plans from specifications,
7. Make the analysis of the problem, develop specifications, and design the article.

It will be well for the design student to keep a notebook in which ideas, trial sketches, and notes are freely recorded. His work should cover many types of problems, each, if possible, carried to complete solution. Excessive time spent in elaborate renderings should be avoided. Power of developing ideas is to be preferred to the ability to make pretty pictures. Whenever working drawings are made they should be full size.

Analysis of a problem by an entire class, or a committee, is good experience. Solutions arrived at after the manner of a "design associates" will bring out the

values of group work. A class should learn to submit work to group criticism and jury appraisal.

The discerning teacher will note that the word art does not appear in the text. This will satisfy both those who see no reason why it should, and those who, like the author, believe the word no longer has meaning. Yet the designer's real goal is the achievement of beauty. His aim "... is not a quick, nor a profitable nor an ambitious, nor an ornamental job, but simply a good one, perfectly adapted to its particular function. Beauty comes as naturally out of it as blossom on a blackthorn, whose object is fruit, not flowers." (Massingham. *The Wisdom of the Fields*)

The author is indebted to his associates and students, both at the Ohio State University and the Millersville State Teachers College, and to his patient and helpful family. Thanks are due Mr. John Metz, The Raymond Loewy Associates, Mr. Henry Kauffman, the Folly Cove Designers, Emile Bernat and Sons Company, and the various museums noted in the text. Special thanks are due Mr. Forrest Crooks for his many suggestions and valued criticisms.

<div align="right">B.N.O.</div>

"Beggarov"
September
1 9 4 6

TABLE OF CONTENTS

What does "design" mean?	1
What can the designer believe?	2
Must the designer consider economics?	3
What are the qualities of good design?	4
How does the designer achieve beauty?	5
How does the designer think out a plan?	6
How are constructed articles described?	7
How does the designer secure order?	8
What is meant by the term "function"?	9
How does balance affect design?	10
What is good proportion?	11
What are the purposes of ornament?	12
How is ornament used?	13
Should the designer understand symbolism?	14
Can the circle be used in design?	15
What is a good curved line?	16
How may curves be combined?	17
How can the designer use wrought iron?	18
What are the design elements in thin metal?	20
In what ways is cast metal used?	22
How has metal been used in folk arts?	24
How has the machine affected design in metal?	25
Does structure influence design in wood?	26
What methods of cutting wood are available?	27
What decorative methods are used on wood?	28
Need the designer know period styles?	29
How is turned work designed?	30
What are the types of turned work?	31
How is a design for turned work used?	32
What are the design elements in clay?	33
How is clay decorated?	34
What are the forms of pottery vessels?	36
How are templates made for pottery?	38
What design variables are there in leather?	39
What decorative processes suit leather?	40
What are the basic textile structures?	41
How are textiles decorated?	42
What is the nature of the tapestry weave?	44
How is pattern weaving designed?	46
How is the block-printed textile designed?	48
How is the stencil designed?	50
How is a repeat pattern developed?	52
Is there a geometry of repeating ornament?	53
What are the types of plastics?	54
Can the handworker use plastics?	55
What are the design elements in letters?	56
What factors influence letter-design?	57
How are new letters derived?	58
What is an appropriate letter form?	59
How is typographic unity attained?	60
How is a regular type mass balanced?	62
Can type pages balance on the vertical axis?	63
How is good proportion attained?	64
How is typography designed?	66
Does paper count in typographic design?	68
What factors make a good bookplate?	69
How is a measured drawing made?	70
How is a "morgue" formed?	71
Problems of analysis of requirements	74
Problems of function	75
Problems of order	76
Problems in balance	77
Problems in geometric form	78
Problems in the use of free-hand curves	79
Problems in wrought iron	80
Problems in thin-gauge metals	81
Problems in cast metal	82
Problems in wood	83
Problems in ceramics	85
Problems in leather	86
Problems in textiles	87
Problems in graphic arts	88
Problems in plastics	90
Bibliography	91

SECRETS OF **GOOD DESIGN** FOR ARTISTS, ARTISANS & CRAFTERS

WHAT DOES 'DESIGN' MEAN?

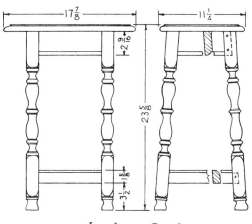

When a house is planned, the architect studies the needs of the owner, and decides what building features are necessary to supply these needs. He organizes these elements into a unified plan, adjusting them to secure the best use of each.

Floor Plan

The furniture designer knows styles, woods, and methods of working and joining parts. His plans show the cabinetmaker all of the essential requirements of form and construction.

Jacobean Stool

A silversmith uses a plan in order to work without waste of time and material. It is much easier for him to make changes on paper than to alter a costly piece of metal, once it is partly shaped.

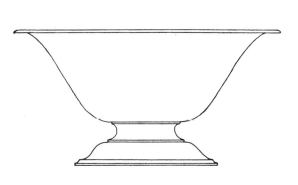

Fruit Bowl

Symbols are short-cut devices designed to convey ideas. They may represent one's country (a flag); an organization (a badge); or a family (coat of arms). Decorative forms are frequently archaic symbols.

A DESIGN IS A PLAN.

EX LIBRIS
ALOIS
CHVÁLA

Bookplate (Czechoslavakia)

WHAT CAN THE DESIGNER BELIEVE?

 These lessons are based on the following creed:

1. Designing is reflective thinking working in visual form.

2. The designing technique (the process of being creative) is identical with the scientific method, and must be developed by study and practice to be effective.

3. Being creative is not an act of spontaneous generation by a mind untrained and uninformed.

4. Emotion, which may or may not accompany creative activity, is the result of the feeling of satisfaction (or lack thereof) in the rightness of the effort.

5. Dexterity, power of visualization, and general intelligence, are the forces that make for competency in designing in the visual arts, as well as constituting skill in producing them.

6. Painting, drawing, weaving, forging - in fact, all visual arts - are produced by the same common elements. Differences in the success of those who practice them are measures of quantity of effort and quality of thinking, rather than differences of kind.

7. Rightness - beauty - is and always has been relative to the times and circumstances. To hold that there are permanent standards of beauty, such as the "golden rectangle", irrespective of when or how used, is, in the language of Croce, to cling to the "astrology of aesthetics."

8. A democratic viewpoint can hold no hierarchy of rank among those who create, except that of the relative social worth of their contributions.

"The effort to make a useful object pleasing to the eye or touch gives the craftsman an understanding of the age-long struggle to bestow on objects of daily use that quality that renders their ownership one of life's events." ~ Allen Eaton, Handicrafts of the Southern Highlands

Must the Designer Consider Economics?

The constructive designer cannot set pencil to paper without making or assuming certain economic and social basic conditions which he should understand if he is to work intelligently.

If he is designing for handicraft production he must expect:

1. Each piece of work is, presumably, a masterpiece.
2. Individuality of design is expected.
3. Some degree of variation from his plans will occur.
4. Duplicating is costly and unnatural.
5. The product of his design is for use.
6. The craftsman, especially when working for himself, cannot afford to waste time, energy, or materials, hence everything he makes must be planned for most effective use, greatest economy of effort in production, and longest use. Hence only the finest of materials should be specified.

Dunkirk Cup, designed by C.J. Shiner

When the designer is planning for machine production a different set of conditions will operate to affect his plans:

1. Since the machine is basically a device for duplicating, the design is planned to facilitate exact repetition.
2. Variations, if they occur, are usually defects.
3. The designer probably will have little to do with actual production.
4. Duplicating the article should be expected and usually reduces costs.
5. The product of the machine is for the market (as compared to production for use).
6. The design must be made to allow for a rate of deterioration of the product through wear or style changes, so timed or made obsolete, that continuous production will result. A durable product or a design giving long satisfaction may ultimately lead to unemployment.

Typical Machine Product

WHAT ARE THE QUALITIES OF GOOD DESIGN?

Baltimore Clipper

1. It is fitted to the purpose for which it was planned. Otherwise, it may be said, the design might better not have been made. Satisfaction in the results of planning is directly proportional to the degree to which this quality is present. The huge dam, braced against impounded water; the sleek, stream-lined combat plane; a Stradivari violin; a Lancaster County barn; and an ax handle, all declare the ability of man to meet problems by trial or by scientific techniques. When well designed,"form follows function."

2. It is suitable to the material of which it is made.

Anvil

A good design discreetly emphasizes the peculiar qualities of a material. It equally recognizes a limiting range for each material. Imitations have no place if this quality is to be attained. New materials are welcomed by the designer when they help him solve new problems, or meet old problems with improved results.

3. It is fitted to the processes by which it is produced.

Snowball Coverlet

Character and distinction are given to an article when it is designed to show frankly, but without exaggeration, the methods by which it is produced. Fakes in production, intended to give a false idea of value, are evidences of dishonesty unworthy of the able craftsman. The skilled designer uses his knowledge of tools and machines to permit correct and, therefore, economical manufacture.

∴ These three qualities demand that the designer be a person of high integrity, with knowledge of the functions of living and of human needs. He must be acquainted with materials, and with techniques of production.

HOW DOES THE DESIGNER ACHIEVE BEAUTY?

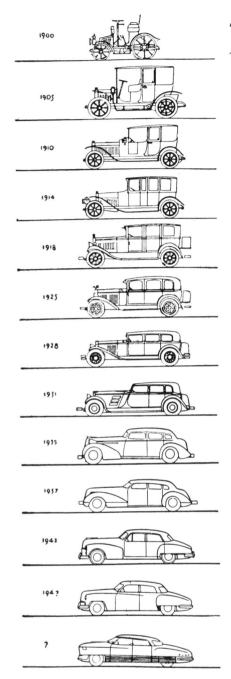

1900
1905
1910
1914
1918
1925
1928
1931
1935
1937
1942
194?
?

Courtesy Raymond Loewy Associates

The automobile is an example of the evolution of a design in search

Perfection of beauty (or the beauty of perfection) may be regarded as the ultimate goal of the constructive designer, regardless of what his product may be. Each designer will have his own concept of what factors contribute to the achievement of beauty. No simple formula can provide an unfailingly successful result, but the following factors, at least, must be considered:

1. Perfection of functions is of first importance.
 a. These must be analyzed.
 b. Materials used must meet demands made on them.
2. All parts of any beautiful object must balance each other.
 a. Analysis must lead to synthesis, with give and take, based on judgment, bringing relative importance of parts or functions into balance.
3. Current social thought and standards affect these decisions.
 a. No design or standard of beauty can be right for all times and places.
 b. Public ideals are apt to lag behind the best informed thought, and seek security in reliance on tradition.
4. Balance and order must be present.

of beauty. Its functions include: 1. Carrying passengers, 2. with ever-increasing speed, 3. safely, 4. with easy handling, and, 5. economy of operation. A constant struggle to achieve a balance of these functions (and economy of production) is evident. First one, then another, predominates. The early models seem to hold the horse-drawn carriage as a standard of beauty. Public acceptance of changes usually lags behind knowledge of improvements. Retrogression from standards of beauty often occurs through novelties used to attract sales.

HOW DOES THE DESIGNER THINK OUT A PLAN?

1. He must understand a need. For example: a movable wall lamp is needed. The designer first sees the problem as a whole, without knowing many of its details. These require further study.

2. He must know standard fixed requirements.—

b. The bulb and 8" parchment shade are to be held at a certain distance from the wall.

a. The light source chosen is a 60 w. Mazda bulb, 4½" high and 2½" in diameter.

c. Once these fixed elements are decided, the problem remains of planning a bracket to hold them in place.

3. He must select the most suitable materials. In this case the bracket may be made of any band form of metal: iron, copper, brass, aluminum, pewter, etc. Other furnishings in the room, cost, strength, durability, and construction methods to be used, each and all influence the selection.

4. He must decide the details of form, line, proportion, and construction. To aid in trying out ideas, the designer makes many "thumb-nail" sketches, always starting with the fixed, or conventional requirements.

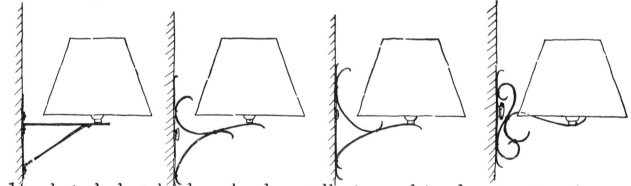

5. He selects the best sketch and makes a full-size working drawing from it.

6. He refines proportions and details.

7. He has the drawing checked by some competent person.

8. He makes revisions where these are necessary.

9. He examines the article made from his drawings to learn how well his idea has worked in practice, and how he may improve on the next design.

Analysis ~ decision ~ trial ~ action ~ judgment ~ improvement

HOW ARE CONSTRUCTED ARTICLES DESCRIBED?

A. By drawings
 1. Sketches and formal technical drawings, made with pencil, ink
 a. Perspective
 b. Axonometric
 c. Exploded
 d. Orthographic
 e. Phantom

 2. Renderings in charcoal, crayon, pencil, ink, color, in any above form

B. Models
 a. Scale
 b. Working
 c. Mock-ups

C. Words
 1. Name of article
 2. Purpose or function
 3. Materials: kind, quantity, quality
 4. Process of producing
 5. Sizes of whole and parts: comparative, measurement
 6. Shape: inclusive and detail
 7. Organization of parts: arrangement, unity
 8. Color
 9. Texture, finish
 10. Style
 11. Effect in surroundings
 12. Designer
 13. Cost
 For an extensive and helpful analysis of descriptive terms, see
 Smith, Janet K. Design: an Introduction. Chicago: Ziff-Davis Pub. Co.

HOW DOES THE DESIGNER SECURE ORDER?

Order in design is the result of a reasoned, logical arrangement of elements. The perception of order tends to promote a feeling of security, with the result that a design giving evidence of order offers lasting satisfactions. Order may be had through a number of means, among which are the following:

1. Through clear evidence of function. Paul Lamerie (London, 1720)

left no doubt as to the purpose of his silver teapot.

2. Through reducing complex combinations of parts or elements to a relatively few simple forms. This may be done, as shown at the right, by emphasis of a few major parts with heavier lines, change of plane or height, or use of different materials. A simple relationship of parts is desirable in giving a unified effect to a design.

Desk and Bookcase from The Cabinetmaker and Upholsterer's Guide, by Hepplewhite.

Analysis of the divisions of the Desk and Bookcase

3. Through regular or sequential arrangement of elements.

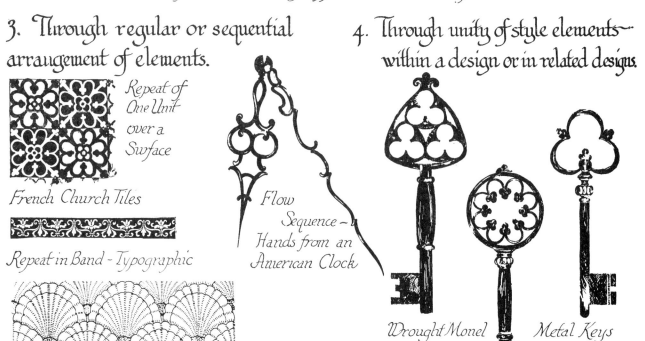

Repeat of One Unit over a Surface

French Church Tiles

Repeat in Band - Typographic

Radial Development - Wallpaper

4. Through unity of style elements within a design or in related designs.

Flow Sequence - Hands from an American Clock

Wrought Monel from the Cathedral at Bryn Athyn,

Metal Keys Pennsylvania

WHAT IS MEANT BY THE TERM 'FUNCTION'?

1. Mechanical Function

Grain Cradle

Wall Sundial

A device is said to function if it 'works'. To design a functional article of any kind, the designer must be an 'engineer'. He must estimate strengths of materials, direction and amount of force, qualities of materials, structure, and operational needs.

Arms of N. Bacon

Girl Scout Emblem

Imprint of Aldus Manutius

Signal Corps Badge

2. Publicity Function

Every design is significant for the message it conveys. A symbol, as those shown above, indicates membership, ownership, position, or interest. Just as 'clothes proclaim the man', so may a building and its furnishings symbolize the stability of government, the social unconcern of the slums, or the pride of a home owner.

3. Other Functions

The chief purpose of a design may also be to give pleasure through its form, line, color, or texture. A craftsman often demonstrates that one of the major purposes is to afford him the pleasure of using his skill, and of expressing his feelings through his work. Any or all of these functions may characterize a design.

12th Century Manuscript Initial "D"

Motif from Swedish Dukagang Weaving

HOW DOES BALANCE AFFECT DESIGN?

Balance is the result of the interplay of forces; the resolution of stress & strain. Its effect is one of repose and satisfaction. Lack of balance creates a desire for change. The designer employs various means to attain balance, such as these:

Leather-bound Book.

1. Through giving evidence of adequate strength. The chair must convince its user that its material and structure will safely bear his weight. A more subtle case is the spacing of the bands in the book to give the effect of a firm base.

Modern Tubular Chair

2. Through a functional relationship of all parts.

3. Through equalized arrangement with respect to an axis, a center of interest, or a line of motion.

Bi-symmetric Balance

A-symmetric Balance

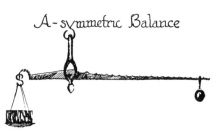

Equal areas on both sides of a central line, equal color value, equal amount and kind of ornament, same arrangement

Large area of:	Small area of:
smooth surface --	ornamented surface
plain grain ---	figured grain
weak color - - -	strong color

Large weight near center of interest - ~ ~
small weight at distance

18th Century Venetian Goblet

Chippendale Key Plate

Modern Silver Brooch

Paradife Loft.
A
POEM
IN
TWELVE BOOKS.

The Author
JOHN MILTON.

The Second Edition
Revifed and Augmented by the fame Author.

LONDON,
Printed by S. Simmons next door to the
Golden Lion in Aldergate-ftreet, 1674.

MODERN BOOK DESIGN
·· Utilizes All The Devices of a new age to secure its novel effects: striking colors, unbalanced pages, simple body type, hand-drawn, appropriate ornament, "bled" illustrations, and fine paper. · · · ·

Good proportion is, to a large extent, a matter of balance between parts; each having the size best suited to its purpose.

WHAT IS GOOD PROPORTION?

What proportions are good? Should articles be tall, wide, or square? The answer is implied in the old fable of the crane and the fox each of whom served the other food in dishes designed for his own mode of eating. Which is to say that there is no *right* proportion apart from the conditions of optimum use of the article.

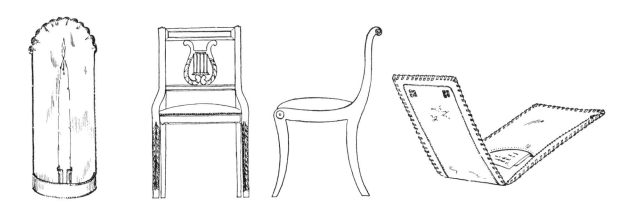

The colonial candle sconce would appear to be very tall for its width, were it not that this shape provides reflection and wall protection for the entire length of the candle. Duncan Phyfe's dining chair is almost a cube at seat height, because of the requirements of fitting the measurements of the seated human body in erect position. Since paper money is of a fixed size, a billfold is much longer than it is wide to conform to the needed shape.

Shaker Blanket Chest

Similarly, the proportions of the several parts of an object are determined by the balance of two forces: (1) securing the optimum service from each part and, (2) adjusting the size & shape of each part to the whole article. In the final analysis no other proportions prove satisfactory.

Certain historic styles depart, at times, from this rule of the analysis of function to secure effects of balance or order. Such proportions are oft attained by employing subtle ratios of length and width (e.g. 1:1618). These ratios inherently have no special merit, and, unless used with skill, may actually interfere with good design.

WHAT ARE THE PURPOSES OF ORNAMENT?

Vents in the base are arranged in an orderly and pleasing pattern.

Hurricane Lamp

1. To establish order and balance in a structural part

In these examples the decoration consists of the orderly arrangement of purely structural parts into an interesting pattern.

Cooking utensils rest on the balanced forged bars in the top.

Trivet

2. To indicate ownership, or the beliefs, interests, religious, fraternal, or political affiliations of an individual. These may be turned to unsocial uses through ostentatious display to indicate wealth or superiority of position.

Bookplate by Vojtech Preissig

Chimney Pot and Weathervane for a Hunting Lodge

by W. Hunt Diederich

Honor Society Key

Monogram of E. G. Gress

Ornament should *not* be used

1. When it obstructs use
2. When it weakens structure
3. When it causes a style anachronism
4. When it is meaningless
5. When it calls for treatment incompatible with the material on which it is used

HOW IS ORNAMENT USED?

Ornament is any planned modification designed to increase interest and signifi-cance as distinct from the minimum structural or mechanical requirements. The mechanical function and the securing of interest may blend into a coherent plan, or the decoration may be obviously an addition.

Brass Door Knocker
Naturalistic

Method of Treatment

Early Watermark
Symbolic

American Hooked Rug
Geometric

Method of Use

Linotype Border after Jenson
Naturalistic Band

New Years Card, Netherlands
Band of Lettering

Ornament from "magic square," Bragdon
Geometric Band

Modern Book Jacket
Naturalistic All-over Repeat

Ornamentation develops from the literal reproduction of objects of nature, the imaginative varia-tion of these figures, and in the logic of straight line, circle ⋯ and more complex curves ⋯

Wrought Iron Grill, European
All-over Geometric Repeat

It may be used in bands (either continuous or broken); all-over patterns (diaper or powdering); and in radial form, either in two or three dimensions.

Indian Basket
Radiating Pattern

An accurate knowledge of historic ornament is necessary for the designer who wishes to work in any of the so-called "periods" of historic style. —

SHOULD THE DESIGNER UNDERSTAND SYMBOLISM?

The designer frequently needs to know how to employ symbolism as a concise and easily-recognized means of identification, propaganda, to express an idea, or to encourage allegiance to a cause. A pictographic symbol is easily remembered since the sensation of the symbol directly recalls the image or idea of the subject. A metaphorical symbol may be less effective, since it is more subject to individual interpretation.

Watermark from 18th Century Mill

Caduceus (medicine)

Religious Monogram

Mountain (Indian)

Triangle (Truth, Stability)

Gardening

Laurel (Fame)

Lamp (Truth, Knowledge)

Printer's Mark

Modern Map Symbols

British Coat of Arms

CAN THE CIRCLE BE USED IN DESIGN?

Humphrey Penn
pewterer's touch

Section of
Ionic
column

Imprint of
the Grolier Club

Gothic
stonework

Maiolica
dish

Chip carving from Early American box

Mirror with
metal frame

Modern
Swedish

The circle is the logical answer to many requirements of structure, form, and motion. Coins, buttons, tableware, and watch faces are examples of common articles whose convenient form is round. In three-dimensional form, bearings and baseballs attest to its necessity.

Mis-use of arcs of circles: (Jacobean turning)

this side designed with arcs of circles

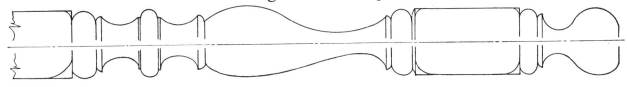

this side designed with free hand curves

Arcs of circles should not be used where traditional practice calls for free hand curves.

WHAT IS A GOOD CURVED LINE?

The line used in fine design for many ages is one sometimes known as the "curve of force." It is a freehand line, no part of which can be constructed with a straight edge or a compass. Such a line is formed by a long wet blade of grass, a young willow branch, or a strong pull on a fine fishing rod.

When it is continued far enough the curve of force becomes a volute.

The volute also occurs universally in nature. Its use in design has been long and widespread.

These curves have curvature ranging *This space reduces in a constant ratio.* an infinite variety in the rate of from very slow to very fast.

Some common errors in drawing these curves:

straight line

sharp break

If continued, the line would cross itself.

Irregular line

Space between lines inconstant

The beginning designer will do well to practice until he has mastered drawing these curves. It helps to start practice on the blackboard, or a large sheet of paper, using a full-length arm motion.

HOW MAY CURVES BE COMBINED?

All curves start with a unit or single element, which is repeated in varied combinations.

element *element* *element* *element* *element* *element* *element* *element*

Single element Two elements forming "S" curve Two elements forming "C" curve

When more than two elements are used in sequence, a break of some sort – a bead, shoulder, or abrupt change of direction – should be used after the second unit.

parallel tangents right angle tangents Special parallel case

When curves are combined, tangents drawn at their ends should either be parallel or perpendicular to each other, and to some axis or surface of the object on which they are used.

Avoid:

Continuous combination Tangents of these curves are not parallel.

Tangents are not perpendicular. Arcs of circles should not be used.

Freehand curves are preferable.

HOW CAN THE DESIGNER USE WROUGHT IRON?

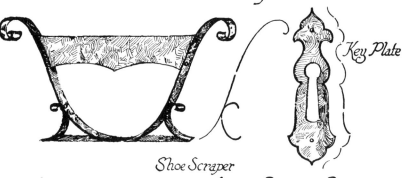

Shoe Scraper

Key Plate

Stag Hinge

1. By giving it fine contour lines. S- and C-curves are commonly used in wrought-iron work.

One of a Pair of Andirons

2. By producing a well-planished surface. The normal process of production of fine iron work calls for the use of stock slightly over the finished size. Reducing, square-to-octagon-to-round-etc, improves the metal, and leaves the surface covered with the honest evidence of construction. A final planishing with a slightly curved hammer face leaves a surface almost as smooth as skill can produce. This surface is one of the chief design elements.

Well-Planished Surface

Avoid exaggerated or useless hammer marks that can only indicate poor workmanship.

3. By indicating clearly and frankly the methods of joining parts.

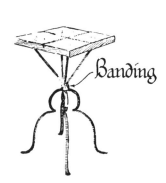

Welding

Banding

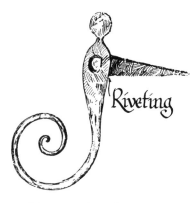

Riveting

End of Curtain Rod

Tile-top Table (Guido)

Shutter Catch

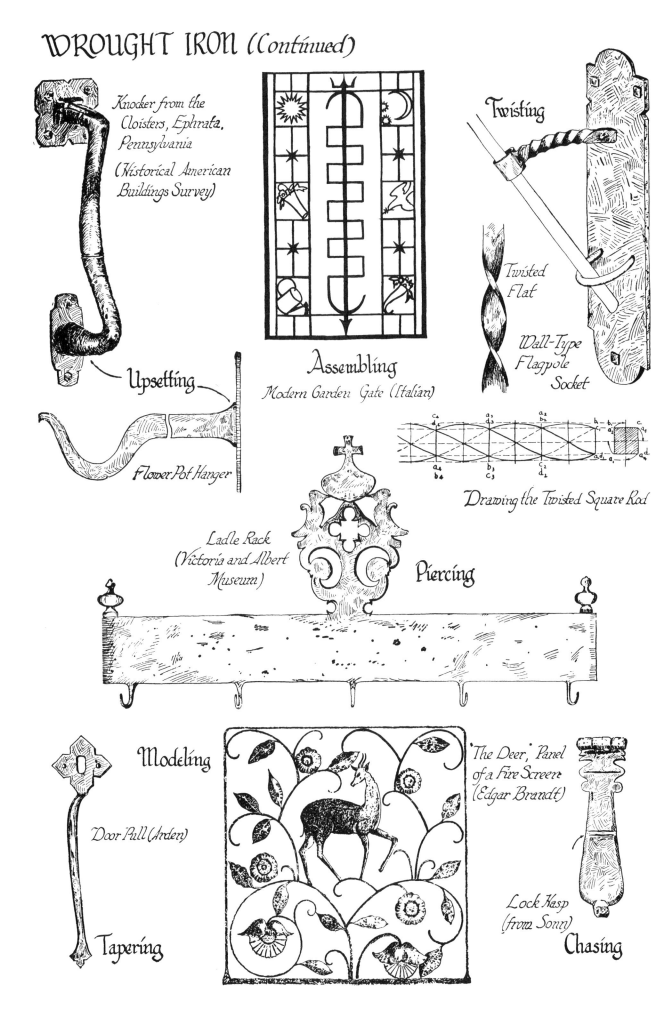

WROUGHT IRON (Continued)

Knocker from the
Cloisters, Ephrata,
Pennsylvania

(Historical American
Buildings Survey)

Twisting

Upsetting

Assembling

Modern Garden Gate (Italian)

Twisted
Flat

Wall-Type
Flagpole
Socket

Flower Pot Hanger

Drawing the Twisted Square Rod

Ladle Rack
(Victoria and Albert
Museum)

Piercing

Modeling

The Deer, Panel
of a Fire Screen
(Edgar Brandt)

Door Pull (Arden)

Lock Hasp
(from Sonn)

Tapering

Chasing

WHAT ARE THE DESIGN ELEMENTS IN THIN METAL?

1. The designer must recognize and use the plastic nature of metals.

Covered Silver Pitcher
Georg Jensen

Spun Pewter Vase
from "Pewter in the Netherlands"

Stainless Steel Plaque
by Oscar Bach
from "Data on
Architectural Metal"

Metals are manufactured in sheets rolled to various thicknesses. These sheets may be cut and bent into shape, or they may be hammered, drawn, or spun. The technique of production should be understood if the designer is to work intelligently.

2. Color and texture of metals are important design features. Colors range from the warm red brown of copper, the yellow of brass, the grays of lead and tin, to the cool brilliance of aluminum, steel, monel, and silver. These colors may be altered and the range increased by oxidation. Surfaces may be mirror-like, or may be given various scratch brush or buffed treatments.

Silver Punch Ladle with Ebony Handle

Thomas Heming
London, 1750

Techniques of construction and ornamentation employed by the designer

Thin Metal Cut and Bent

One piece of very thin brass cut with scissors

Molding and Vitreous Enamel

Silver powder box with narrow flat bands twisted to form moldings. Square strips may be used, or two or more round wires twisted together. The top is decorated with colored vitreous enamel.

Contrasting Colors, Panel Construction

Pewter stamp box made of flat sheets soldered together. Boxes, vases, teapots, etc., may be made with panels in square, hexagonal, or other shapes, and with straight or curved sides. The quill is in copper to provide contrast.

Piercing and Sawing

Iron wall light with inscription formed

by sawing out the letters which may be left open or backed with colored cloth.

Etching

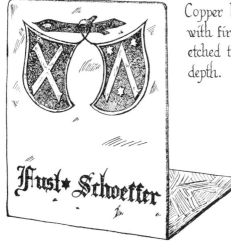

Copper book end with first colophon etched to a slight depth.

Silver tobacco box by Henry Cowper, London, 1792, with engraved bands.

(Wyler)

Engraving

IN WHAT WAYS IS CAST METAL USED?

1. For producing duplicate parts. Castings may be made in molds of sand, plaster, metal, cuttlefish bone, or stone. Exact duplicates are possible in any desired numbers.

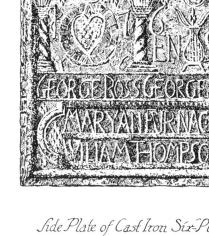

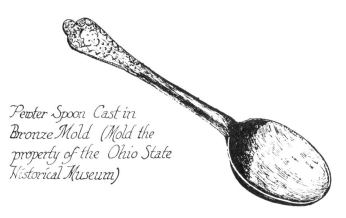

Pewter Spoon Cast in Bronze Mold (Mold the property of the Ohio State Historical Museum)

Side Plate of Cast Iron Six-Plate Stove Cast at the Mary Ann Furnace (from The Bible in Iron, by Dr. Henry Mercer). Probably poured in an open sand drag.

2. For objects requiring weight.

3. For objects impracticable of production by other means.

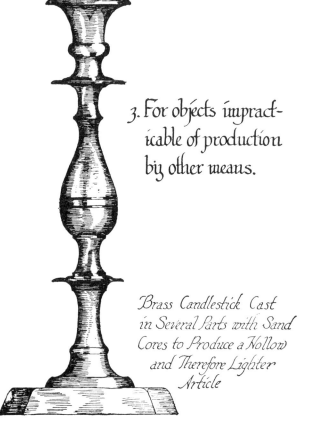

Brass Candlestick Cast in Several Parts with Sand Cores to Produce a Hollow and Therefore Lighter Article

Brass Door Stop after Traditional Hessian Andirons, an Eighteenth Century American Design

CAST METAL, Continued

The casting technique frequently is useful for producing accessory parts, such as knobs, finials, feet, or handles.

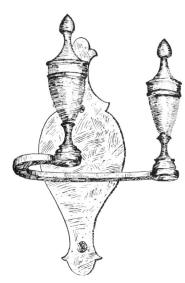

Brass Dog's Foot for Duncan Phyfe Table (I. Sack)

Brass Jamb Hook for Fire Tools with Cast Brass Finials (Ball and Ball)

Two Late Seventeenth Century Furniture Drop Pulls

Pewter Porringer with Handle Cast by H.J.Kauffman, after an Original by Boardman

Casting in Cameo Relief
Paper Knife (from 'Pewter in the Netherlands')

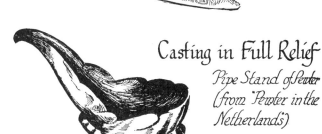

Casting in Full Relief
Pipe Stand of Pewter (from 'Pewter in the Netherlands')

HOW HAS METAL BEEN USED IN FOLK ARTS?

These designs are typical of those based on traditional subjects and forms by groups living long in close identity.

Navajo Gato (bow-guard)
Cast in Silver

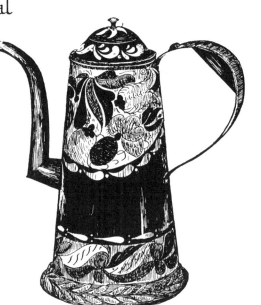

Pennsylvania-German Painted Tin
Coffee Pot, Eighteenth Century

Copper Ornament Made by the Moundbuilders
Sketched from Original in
Ohio State Historical
Museum

Sheet-Iron Inn Sign
Flemish, c.1800

Brass Harness Ornament
Austrian Alps, Nineteenth Century

Bronze Hairpin, East Bohemia

(Last three items from "Peasant Art in Europe," Bossert

HOW HAS THE MACHINE AFFECTED DESIGN IN METAL?

Since the industrial revolution, increasingly greater quantities and proportions of metal goods have been produced by the machine. This has altered fundamentally the basic design of metal articles.

1. It has made possible rapid, exact, and virtually unlimited duplication through the mechanization of basic processes. (e.g. drop forge)

2. It has developed new methods having little or no basis in handicraft techniques. (e.g. extrusion, sandblasting)

3. Machine production has eliminated any reason for imitating the effects of hand tool methods on appearance.

4. Rapid copying of successful designs is made possible.

5. Articles must be designed for quick consumption in order to keep the machines going. The result is an increase in the methods of artificial obsolescence, such as the pressure on style changes in automobile design.

6. Speed of motion, made possible by machines, has brought need for reduction of fluid resistance. Streamlining has, quite illogically, tended to influence the design of articles not meant for motion.

7. Distinctive personal, regional, or national characteristics tend to be eliminated.

8. Detailed designing in advance of production becomes necessary, since fabrication probably will be done by numerous unskilled machine operators who, lacking the early craftsman's complete mastery, will be unable to work without external control.

DOES STRUCTURE INFLUENCE DESIGN IN WOOD?

The designer, especially when he is the cabinetmaker, learns to take advantage of the special qualities of grain - texture, color, figure, direction, and feel.

*American Walnut Table
Eighteenth Century*

*Writing Desk - American Wing.
Metropolitan Museum of Art*

Modern Desk

Solid wood expands and contracts across the grain, so provision is made (in overhang of top) for change of size.

When built-up panels are used, edges may fit to exact size, since practically no change of size occurs.

Matched curly maple front

Contrasts in side and end grain show up in visible joints, as decoration.

Modern Coffee Table - French

American Walnut Chest

Modern laminated construction, made under tremendous pressure and with waterproof glues, for house walls, airplanes, furniture, etc., makes possible forms and uses beyond the power of the hand-worker, who should not copy them.

grain

Claw-and-Ball Leg

Certain cuts (in this instance turning) bring out interesting grain effects.

An "engineering" requirement calls for knowledge of grain strength.

*Cigarette Box
German*

WHAT METHODS OF CUTTING WOOD ARE AVAILABLE?

Carving

Panel from Sunflower Chest
Flat surface with background lowered

Ship Figurehead
Carved in full relief

Fifteenth Century Panel
Raised pattern on flat background

Turning

With Fluting

With Reeding

Plain Turning

Spiral Turning

Sawing

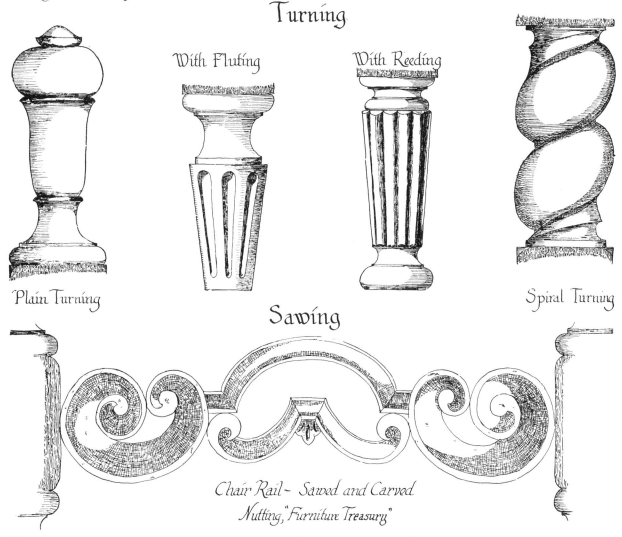

Chair Rail~ Sawed and Carved
Nutting, "Furniture Treasury"

These methods are used singly and in combination in endless variety of form.

WHAT DECORATIVE METHODS ARE USED ON WOOD?

Inlays of vari-colored woods are used in contrasts with backgrounds in the form of line or elaborate decoration.

Carved Butter Mold Landis Valley Museum

Painted figures are applied directly to wood surfaces as decoration and protection.

Inlaid Chair Panel 16ᵗʰ-17ᵗʰ Century Marx and Taylor, Measured Drawings of English Furniture"

The natural colors of wood are altered or intensified by the use of bleaches and stains. Surface textures are further developed with oil, wax and varnish as may be appropriate.

Painted Chest Panel, 1787
Pennsylvania Museum of Art

Splat from Chippendale Chair
Piercing and Sawing

Picket Fence and Gate
Balanced and Orderly Arrangement of Parts

NEED THE DESIGNER KNOW PERIOD STYLES?

What are "period styles"? A relatively unified and consistent treatment of construction, materials, form, and decoration, maintained for sufficient time to become established. Styles have their origins in social traditions and customs, in political movements, in commercial stimulation, and in the ideas of a dominant designer.

Styles have evolved

from

the use of simple native materials, close and sympathetic relation to architecture, the craftsman's ideals of enduring construction, retention of significant decoration and form, little regard for comfort, fitting the organic growth of the family as an enduring institution, the expression of a people's philosophy of living, regional or national acceptance, and slow change,

Italian Seat
15th century

Elizabethan
Draw-Table 16th c.

William and Mary
Highboy 17th century

Hepplewhite
Sideboard 18th cent.

toward

a world source of material, random relation to architecture, commercial standards of construction, search for new forms, decoration without significance, goals of luxury and comfort, prepared for temporary use, of relation to the philosophy of the day only as it indicates a lack of convictions, international acceptance, "smartness" and sophistication, and rapid change.

Louis XV
Side Chair
18th cent.

American
1850

French
1925

American
Contemporary

How are these styles used today? The modern designer accepts traditional styles largely because he is unable to devise anything else the public will accept. Furniture designing is divided, in the main, between rather inept modifications of the traditional forms, and a few sincere attempts to produce purely functional articles without regard for history. If the period styles are to be followed, they should, at least, be correct.

HOW IS TURNED WORK DESIGNED?

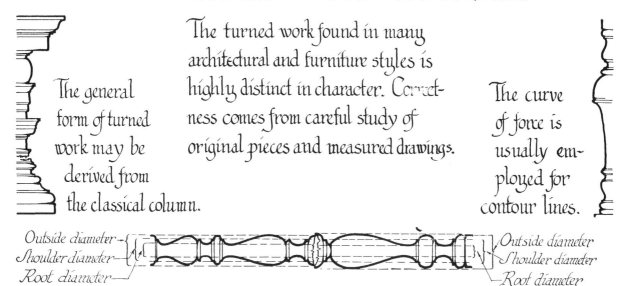

The general form of turned work may be derived from the classical column.

The turned work found in many architectural and furniture styles is highly distinct in character. Correctness comes from careful study of original pieces and measured drawings.

The curve of force is usually employed for contour lines.

Outside diameter —
Shoulder diameter —
Root diameter —

Outside diameter
Shoulder diameter
Root diameter

Forms generally are simplified to a very few different diameters.

As a rule designs consist of one or two elements (such as the vaseform) repeated in one or another of various combinations with a connecting element between.

The elements are joined by shoulders, or beads to avoid the monotony of long and unbroken curves. Long curves may be interrupted by small rounds or coves in varied combinations.

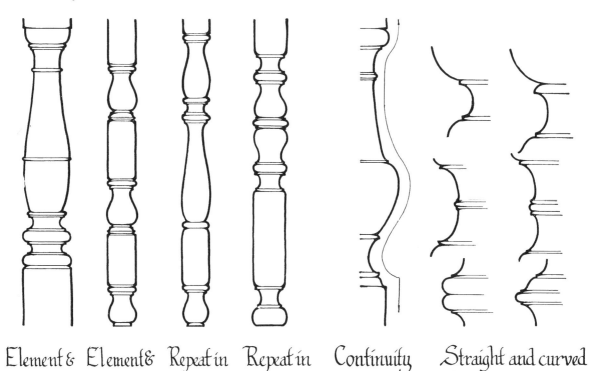

Element & variation Element & repeat Repeat in reduced size Repeat in reverse Continuity with breaks Straight and curved shoulders, coves, & beads

WHAT ARE THE TYPES OF TURNED WORK?

As to Use

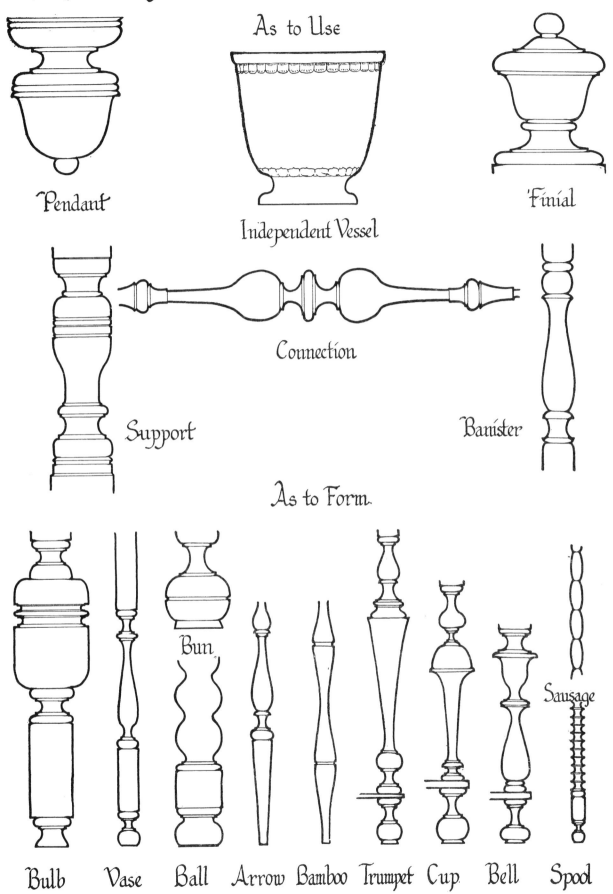

Pendant

Independent Vessel

Finial

Support

Connection

Banister

As to Form

Bulb Vase Ball Arrow Bamboo Trumpet Cup Bell Spool

Bun

Sausage

HOW IS A DESIGN FOR TURNING USED?

Seat Square

Turned

Square

Turned

Chair Leg

1. Lay off all fixed dimensions, and areas not to be turned, such as the squares for joining rails and stretchers.

2. Outline major diameters, and size of square stock to be cut.

3. Fold a piece of paper and lay off on one side the previously determined dimensions in full size.

4. Draw contours in detail and exact outline.

5. Cut away paper outside lines.

6. Open, connect points, and examine pattern. Make corrections or try another pattern.

7. Paste this pattern to a piece of thin wallboard, pressboard, or thin veneer. Extend all arrises to edge of mounting board. This will permit the accurate and rapid transfer of all points to the revolving stock through the touch of a pencil.

8. By setting calipers to actual diameters on the pattern depth cuts may readily be made. The turning is completed by connecting these points by eye.

The lathe is an excellent example of a tool whose use distinctively affects the product. It differs from straight line cutting tools (such as the plane) in that it imposes few restrictions on form. Designing for the lathe is made more difficult by this very freedom. Order and balance must be guarded vigorously lest the result be only chaos. As a rule simplicity helps to produce work most likely to give lasting satisfaction.

WHAT ARE THE DESIGN ELEMENTS IN CLAY?

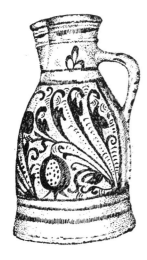

Spanish Water Jug
Bossert

1. Adaptability to many uses. Clay has been, from time immemorial, one of the chief materials by which man has met his needs for utensils, building materials, and many other uses. Within the limitations imposed by the nature of the material and the processes of production, rightness of use holds first place in design. For instance, in a pitcher the base must be large enough to prevent upsetting, capacity must be adequate, weight must not be excessive, the handle is placed to give easy grip and balance, while the lip is designed to prevent spilling and dripping.

2. Great plasticity of clay. Perhaps the most plastic of all materials, it can be modeled, pressed, cast, and thrown, with ease. Its consistency may range from a stiff body to a liquid.

3. Varied textures and qualities of materials. Fine translucent porcelains, heavy rough stoneware, soft red and gray clays offer a range suitable for many uses. Glazes are opaque or transparent, glossy or matt.

Congo Chess King
Paul Bogotay

4. Fine line and functional proportion of parts, response to an eye for fine line. As with other materials good proportion is largely a matter of judgment of relative functional demands of various parts, and a balancing of those demands.

Clay is readily formed to give

Stoneware Cookie Jar
Arthur Baggs

5. A great range of color. In addition to the natural colors of clay, there is a great variety of earth & chemical colors in glazes.

property
Syracuse Museum

HOW IS CLAY DECORATED?

From earliest times articles of clay have been favored for the expression of significant decoration. Religion, tribal history,

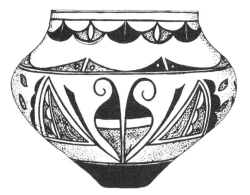

Modern Southwest American ~ San Ildefonso Pottery

and traditions, with interpretations of natural phenomena have a prominent place in devices used in decorating pottery.

In sgraffito ware decoration is scratched through a thin clay coating to expose body clay of a second color.

Slip decoration consists of applying liquid clay in color, with brush or quill to the unfired ware.

Slip-decorated Pie plate by Benjamin Bergey, 1838. Pennsylvania Museum

Sgraffito Ware from Pennsylvania, 1786

Underglaze painting is applied in varied colors to the bisque ware to produce effects, such as the naturalistic treatment of doe and fawn

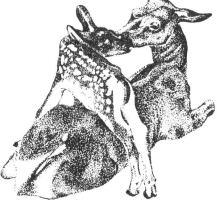

Modern Italian

or the symbolic Indian motifs. These painted pieces may be given a transparent glaze over the color, or, as in most primitive work, a dull unglazed surface is left.

CLAY DECORATION (Continued)

Glaze makes up one of the most effective decorative devices, besides serving as a water-proofing material. Special effects are used, such as crackle glazes, viscous forms that flow irregularly over the ware, crystalline effects, enamels, salt glaze, luster, and many others.

Breakfast Ware, The Dedham Pottery
(from "Contemporary New England Handicrafts")

Rookwood Incised Tile
(from Dougherty)

Raised decoration may be formed above the surface of ware, as shown here, or as used by Wedgwood in his famous jasper ware. Incised forms may have either the background or the pattern cut slightly below the surface. A second color clay may be inlaid in the incised area. The related intaglio method removes a narrow line to outline the pattern.

Chinese Peachbloom Chrysan-
themum Bottle

Decoration may be formed by piercing the clay in some arrangement. These areas may be filled with glaze. Household wares are frequently decorated by the use of transfer sheets printed from copper engravings and other printing methods.

WHAT ARE THE FORMS OF POTTERY VESSELS?

Vessels are commonly made with foot, body, and neck, with appropriate lip, handle, spout, or lid, as use may indicate. The body is the principal part whose form usually dominates the remainder of the piece.

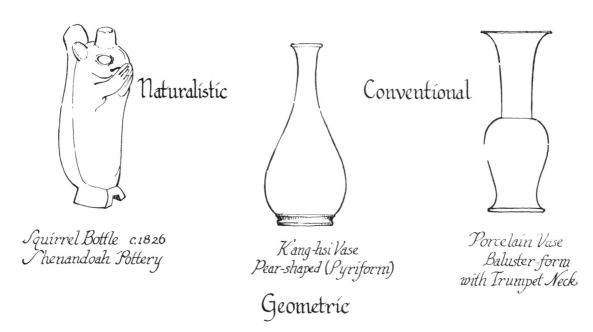

Naturalistic

Conventional

Squirrel Bottle c.1826
Shenandoah Pottery

K'ang-hsi Vase
Pear-shaped (Pyriform)

Porcelain Vase
Baluster-form
with Trumpet Neck

Geometric

Flat-sided forms of 3, 4, or more sides in truncated pyramidal shapes for slab and hand-built construction. These right regular figures may be inverted.

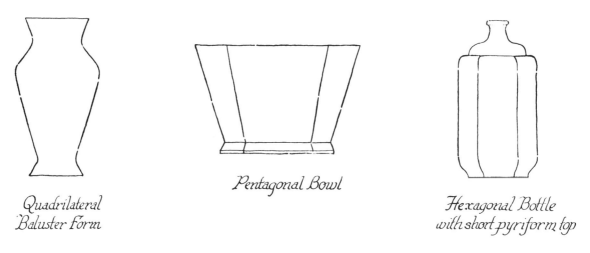

Quadrilateral
Baluster Form

Pentagonal Bowl

Hexagonal Bottle
with short pyriform top

The feet and neck of geometrical-shaped vessels usually follow the same figure as that of the body, although transitions to other figures may be made, as in the *sake* bottle at the right. Conventional or naturalistic handles and other appendages may be used with these geometric figures.

POTTERY FORMS (Continued)

The potter's wheel (with its machine counterpart the jigger) has greatly influenced pottery forms which are, in consequence, usually circular in section. In profile the more complex geometric forms thrown on the wheel assume the general shape of the sphere, spheroid, cylinder, cone (ellipsoid, paraboloid, hyperboloid) or ovoid, with combinations of these, as well as baluster and pyriform.

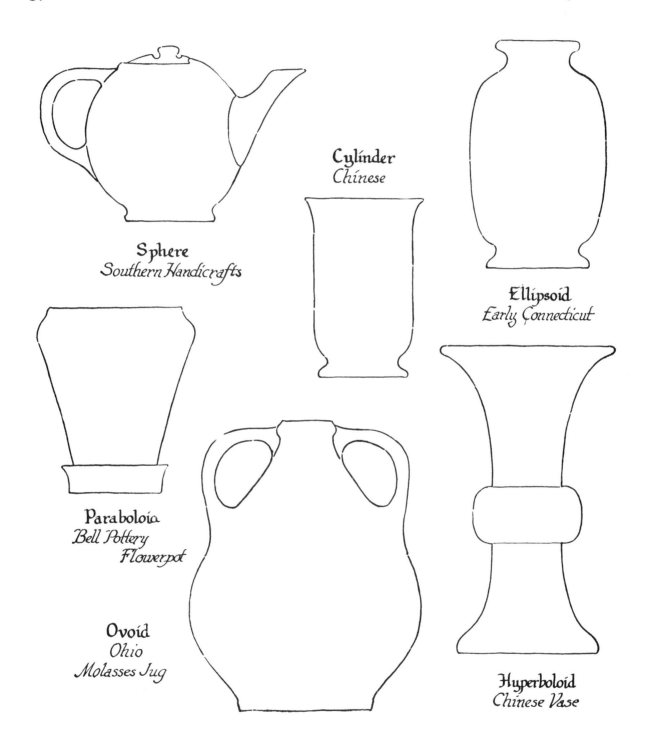

Sphere
Southern Handicrafts

Cylinder
Chinese

Ellipsoid
Early Connecticut

Paraboloid
Bell Pottery
Flowerpot

Ovoid
Ohio
Molasses Jug

Hyperboloid
Chinese Vase

HOW ARE TEMPLATES MADE FOR POTTERY?

In contrast to their use on wood and metal, sharp arrises are not made on pottery. Not only would use quickly chip them, but surface tensions in the liquified glazes, during firing, make it virtually impossible to produce a sharp edge. Hence the designer plans flowing lines that move smoothly from one curve to another.

The inexperienced potter will do well to plan forms on paper before starting work on the clay, first studying all fixed requirements of the problem.

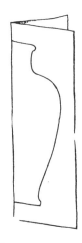

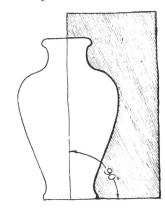

1. After "thumb-nail" sketches have been made to study the problem, a full-size drawing is made (with half diameters) on folded paper.

2. This folded pattern is cut out with scissors.

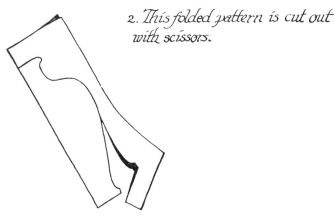

3. The pattern is opened, examined, and improved.

4. The pattern is laid on pressboard or cardboard and its outline is traced. The inside of the pressboard is cut away with a sharp knife forming a template of the remainder.

Template in use

WHAT DESIGN VARIABLES ARE THERE IN LEATHER?

*Morocco-bound Book
from "Swedish Modern"*

1. A large number of varieties are available to the craftsman and to machine processes. Each of these varieties has characteristics making it especially suitable for specific uses.

2. Leather is easily cut and assembled into desired forms.

3. It has long been a mainstay for meeting many human needs, and continually their number and range increase.

*Carved and Modeled Leather
Spanish Chair*

4. Leather is readily decorated by a number of processes, most of which leave a permanent effect.

5. Color, texture, finish, thickness, flexibility, modeling capacity, cost, and availability must be considered.

6. Designs should take into account the durability of leather. If the vagaries of style changes are ignored, designs should be made for lasting service.

*Bag by Konrad Pfennig
from "Deutsch Werkkunst der Gegenwart"*

WHAT DECORATIVE PROCESSES SUIT LEATHER?

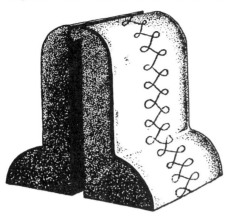

1. The natural markings of many leathers, such as alligator or ostrich, are sufficient decoration in themselves. Artificial textures, suede, polished, or embossed, increase the variety of basic surfaces.

Leather Covered Book Ends with Tooled Decoration from America House, N.Y. City

2. Colors, inherent in the material or added by stain or dye, provide opportunities for harmonious adjustment to other articles.

3. Contrasting colors may be inlaid, or fastened as an applique to the surface.

Pencil with Reptile Leather Cover — America House

Mexican Tooled and Embossed Card Case

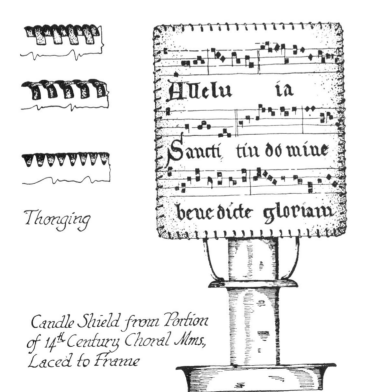

Thonging

Allelu ia

Sancti tin domine

bene dicte gloriam

Candle Shield from Portion of 14th Century Choral Mms, Laced to Frame

4. Leather may be tooled, carved, or embossed, and left blind, or gilded.

5. Thonging (or lacing) in great variety of forms, adds a note of interest as well as serving a structural function.

6. Strips, used for handles, etc., may be plaited to increase strength and interest.

WHAT ARE THE BASIC TEXTILE STRUCTURES?

Coptic Weaving
Boston Museum of Art

The textile designer must understand thoroughly the structure of his medium.

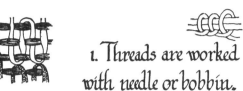

1. Threads are worked with needle or bobbin.

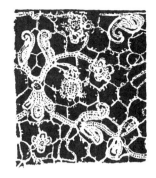

Venetian Rose-point Lace
Pellew, Seven Centuries of Lace

2. Weft threads are interlaced at right angles to warp threads to weave varied patterns.

3. Fibers are matted or felted in random arrangement.

Tapa Cloth

4. Yarns or strips are drawn through a base or twisted into warp and weft in pile fabrics.

American Hooked Rug

5. Cords are twisted together and tied.

Tassel from an Edging

Knitted Mittens

6. Yarns are drawn through loops in a continuous chain.

HOW ARE TEXTILES DECORATED?

The most basic decorations are produced by variations in kind, texture, color, number, and arrangements of yarns and threads, as the cloth is woven.

A simple fabric may depend on texture for its decoration. This may be smooth or irregular.

Cloth of Irregular Wool Yarn

Decoration is woven into tapestry, and similar fabrics, by carrying yarns of various colors back and forth in certain areas.

Common Twill

Simple weaves may be arranged to raise one color, then another, to the surface in some regular order.

Decoration may be produced, in addition to the methods described, by close or loose weaving, by leaving open areas, by pulling threads out of their usual rectangular order, or by a combination of two or more of these methods.

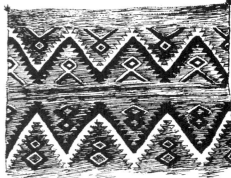

Portion of Southwest Indian Blanket

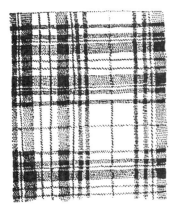

'Royal Stuart' Tartan

Color, introduced in warp and weft, produces tints and shades at intersections.

The designer who works in these forms must understand the techniques of weaving.

Variation of the 'Lovers'Knot' Overshot Weave

Limitless variation may be produced by bringing warp or weft threads to the surface as "floats" over the body of the cloth.

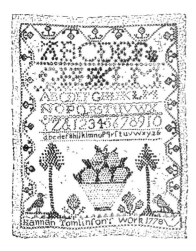

*American Sampler
Cross-Stitched*

Colored threads are stitched to a base to form a partial or an all-over pattern.

Certain threads are drawn out, and the spaces partially filled with needle-work.

*Cap of Charles V
Drawn and Embroidered*

Stencils are cut and laid over cloth. Inks are brushed or scraped through the openings to print the pattern.

Pile fabrics may have certain areas clipped to a shorter length to produce a decoration.

Japanese Stencil

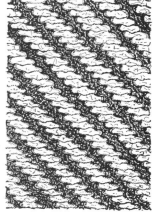

One of Four Units from "The Gossips" by the Folly Cove Designers, Gloucester

Block Print Luncheon Set

Figures are cut on blocks, which are coated with ink and pressed onto the cloth. Intaglio processes also are used.

Pattern areas are coated with wax as a protection, and the cloth is dipped in dye to color remaining areas. This may be repeated on other portions in other colors.

*Cut Velvet
Victoria and Albert Museum*

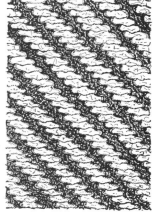

Javanese Batik

WHAT IS THE NATURE OF THE TAPESTRY WEAVE?

The tapestry weave is the freest, least mechanical of all the processes of weaving. Its gamut of types and possibilities extends from the very rigid and relatively simple geometric patterns of the Navajo to the ten-thousand-shade naturalistic masterpieces of the French Gobelins. The nature of the pattern and the technique of weaving, particularly the joining of color areas, are closely related, so technical understanding must precede designing.

Portion of a Tapestry by Bertha Möller

Since all such weaving is rectangular in structure there are no curves in the design. Areas are outlined by horizontal and vertical lines, only. Oblique outlines move by steps, each of which is a multiple of the weft threads (vertical development), or of a variable number of warp threads (which will extend the pattern horizontally). These are counted in the pattern.

TAPESTRY WEAVE (Continued)

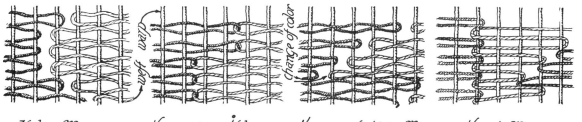

Kilim Weave Norwegian Åklae Norwegian Lightning Weave Navajo Weave

Design for a Tapestry, Adapted from an Old Norwegian Pattern, by Elmer Wallace Hickman courtesy "The Weaver," published by Emile Bernat & Sons Company
Key: *French Tapestry Wool ~ 108 warp threads 1 square = 2 warp threads* ◐ *Y. Red* ⊘ *Olive Green* ◉ *Y. Gold* ⊠ *Powder Blue* ☐ *Cream* ■ *Antique Black* ⊟ *Sage Green*
Colored pencils are used on squared paper to develop the color scheme.

HOW IS PATTERN WEAVING DESIGNED?

The structural basis of pattern weaving is the process of causing a weft thread to lie across two or more warp threads. (This may be reversed to bring warp to the surface.) Since this overshot type of weaving is very frequently used on the four harness loom, a design is shown as developed for that loom.

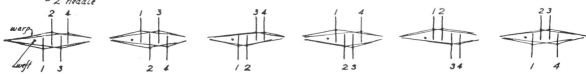

The above diagrams show that there are six possible combinations of four frames (worked in pairs): 1-3, 2-4, 1-2, 2-3, 3-4, and 1-4. The first two, used alternately, produce a simple over-and-under cloth. The remaining four combinations form the pattern blocks. Hence it becomes evident that only four different lines (or "picks") of weft may be used in a design.

The designer uses squared paper on which the pattern blocks are laid out. In this simple diamond pattern all blocks are of equal size. From this diagram is developed the draft for drawing in the warp. Each horizontal row represents one frame, and each block a warp thread. Any one of the four combinations may be used for the first pattern block. The second block begins with the last thread of the first block, and uses the next pair of frames. This leads to the third, and it, in turn, to the fourth. Thus, all four combinations are used, and may be repeated as many times as necessary.

PATTERN WEAVE (Continued)

The draft illustrated before can be used as the basis for pattern variations of the diamond form. The same warp is used, but the order and length of the blocks are changed. Additional changes come with the use of two or more colors.

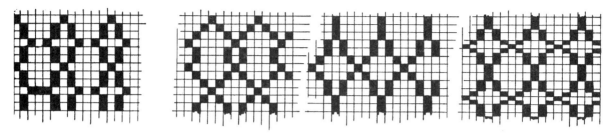

The diamond pattern can be further varied by adding other blocks. These changes call for different drafts.

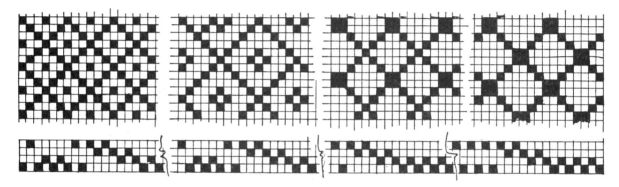

Below are two of the innumerable traditional patterns with a portion of the draft of each. The weaving designer frequently starts with one of these and develops a variation of his own.

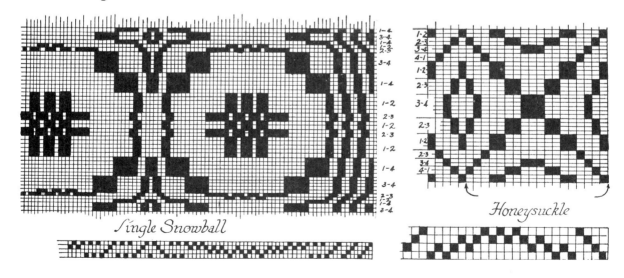

Single Snowball

Honeysuckle

HOW IS THE BLOCK-PRINTED TEXTILE DESIGNED?

Textile prints include every variety of subject, expressed in geometric, conventional, or naturalistic form. One, two, or more blocks (repeats) may be used in the design. The repeat arrangement is somewhat deter-mined by the pattern, but usually is based upon a square or diagonal plan.

Single Block Repeated Each Square

Single Block Alternate Squares

Diagonal Arrangement

Random Placing

Columnar Arrangement

One Block Reversing Background (Counterchange)

One Block Reversing Color in Alternate Blocks

Block Dropped Half Its Height

Rotated 180° in Alternate Blocks

Rotated 45° in Alternate Blocks

A Sequence of Several Blocks
"The Gossips," Courtesy Virginia Lee Demetrios, The Folly Cove Designers

Since the ordinary stencil must provide for the ties to hold its parts together, these should not interfere with the pattern, or better, should become part of the design.

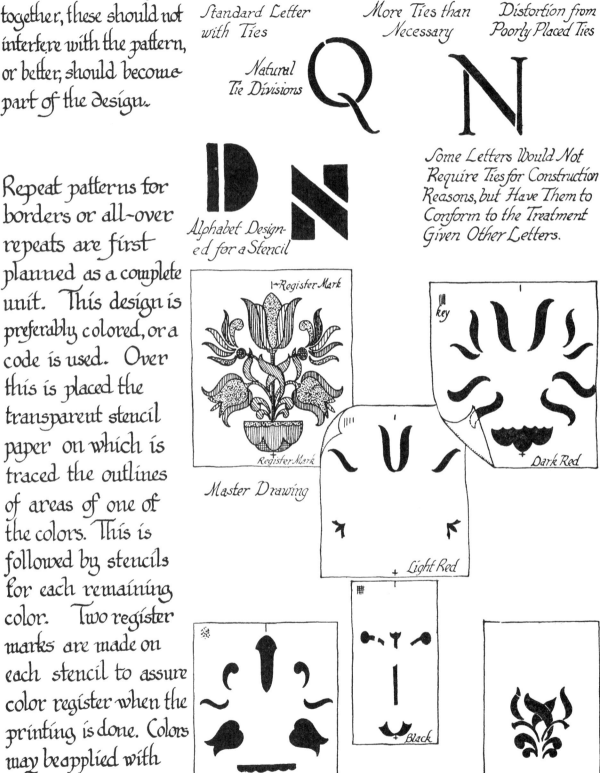

Standard Letter with Ties

More Ties than Necessary

Distortion from Poorly Placed Ties

Natural Tie Divisions

Alphabet Designed for a Stencil

Some Letters Would Not Require Ties for Construction Reasons, but Have Them to Conform to the Treatment Given Other Letters.

Repeat patterns for borders or all-over repeats are first planned as a complete unit. This design is preferably colored, or a code is used. Over this is placed the transparent stencil paper on which is traced the outlines of areas of one of the colors. This is followed by stencils for each remaining color. Two register marks are made on each stencil to assure color register when the printing is done. Colors may be applied with brush, crayon, or air brush.

Register Mark

Register Mark

Master Drawing

key

Dark Red

Light Red

Black

Yellow

Green

STENCIL PRINTING ON TEXTILES (Continued)

The first decision in any silk screen design is that of the process to be used in making the stencil: film (or paper), tusche (brush or crayon), or photography.

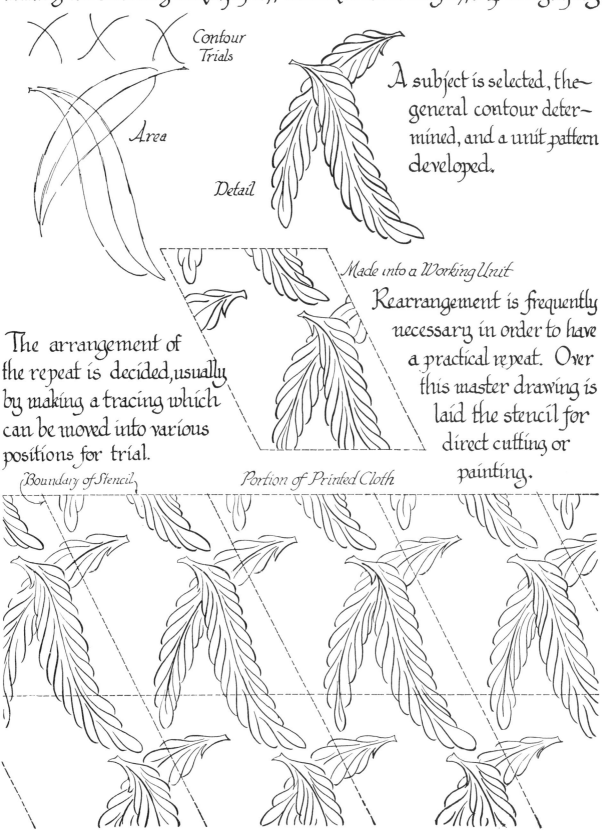

Contour Trials

Area

Detail

A subject is selected, the general contour determined, and a unit pattern developed.

Made into a Working Unit

The arrangement of the repeat is decided, usually by making a tracing which can be moved into various positions for trial.

Rearrangement is frequently necessary in order to have a practical repeat. Over this master drawing is laid the stencil for direct cutting or painting.

Boundary of Stencil

Portion of Printed Cloth

HOW IS A REPEAT PATTERN DEVELOPED?

Ampersand from Goudy, The Alphabet

1. Draw one unit of the repeat.

2. Make a tracing on each of several sheets of tracing paper.

3. Move these about until a desirable space-filling arrangement is achieved.

Original unit with repeat in reverse

4. Draw a boundary line to form a practical block, or stencil. This boundary should cut off projecting parts.

5. If possible, divide at some point or line of natural separation.

6. It may be necessary to move a portion from one side to another to indicate moving of the pattern. (see B)

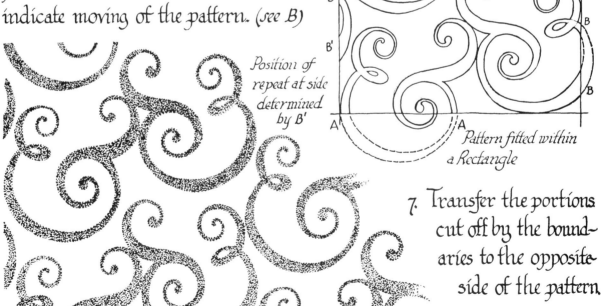

Position of repeat at side determined by B'

Pattern fitted within a Rectangle

7. Transfer the portions cut off by the boundaries to the opposite side of the pattern.

Printed Pattern

IS THERE A GEOMETRY OF REPEATING ORNAMENT?

Polya, Speiser, Bradley,* and others, have developed a special field of geometry based on the problem of fitting together polygons to cover a plane surface so they fill the space without gaps, and without overlapping.

The most common type of repeating design is that based on the division of the plane into congruent parallelograms. The single figure multiplies principally by three methods:

Translation

Reflection

Rotation

"*Translation* means a motion of the plane in itself a given distance in a given direction.... *Reflection* means a rotation of 180° of the plane in space about a fixed line, called the axis of reflection.... *Rotation* means a turning of the plane in itself about some point through a given angle."*

Bradley describes five types of parallelogram assemblages, formed by the general parallelogram, the rectangle, the rhombus, the special rhombus formed from two equilateral triangles, and the square. Each has its own set of motions.

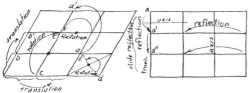

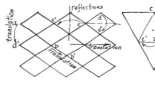

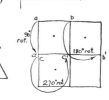

Translations may be made in two directions, parallel to the sides. Rotations of 180° are made on the center of a side, the vertices,

or the intersection of diagonals. Rectangles add to these a set of reflections, whose axes are sides of rectangles.

Rhombuses have about the same properties as rectangles.

The special rhombus has the slide reflections of general rhombus plus rotations of 120° and 240° about centers of triangles.

Squares have motions of rectangles plus rotation of 90°, 180°, and 270°.

* Bradley, A. Day. The Geometry of Repeating Design. Bureau of Publications, Teachers College, Columbia University, New York City, 1933. vi + 131 p.

WHAT ARE THE TYPES OF PLASTICS?

The industrial designer has at his disposal a long list of plastics whose properties are versatile enough to include almost any desired characteristic.

Radio Case

Major types are thermosetting, which become permanently set after molding, and thermoplastic, which can be softened by heating and reformed.

Forming is done principally by subjecting the raw material to high pressure in metal molds, with or without heat, or by pouring into lead molds, followed by baking. Aside from commercial products, completed in the molding, plastics reach the consumer in sheets, rods, tubes, laminated structures, or in novelty forms to be cut to size and finished by hand. Paints, and lacquers made from these materials are increasingly common. Characteristics of different varieties range over a long list of qualities. Some are opaque, others translucent, or transparent. Black, white, or a hundred colors are available. Low or high dielectric strength, light fastness, resistance to acids, alkalis, solvents, or water, may be had. Fire and heat resistance, low thermal expansion, and freedom from taste are possible.

Sweeper Housing

The designer of plastic articles often follows a "modern" streamlined style, partly because it is appropriate to do so, and partly because of the nature of the material and the molding process. Large surfaces are often broken up to obtain a better finish. Reeding, fluting, or other ornament cover "flow lines" on side opposite ribs. Fillets, rounds, and rounded corners add strength and are more easily molded, and more economically cleaned.

Laminated Gear

CAN THE HANDWORKER USE PLASTICS?

A considerable supply of pre-cast forms is available, demanding a minimum of thought and effort to use.

Care must be exercised in built-up articles to avoid the effect of a juggling act.

Products made by hand from standard plastic forms cannot, of course, be further processed by the basic methods by which plastic articles are manufactured, but must employ wood & metal-working processes. Until means are found for performing the basic plastic processes by hand these materials remain rather in the class of appendages or gadgets. The designer is restricted, therefore, to planning minor variations on standard forms.

Plastics combine well with other materials.

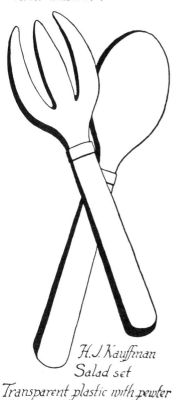

H.J. Kauffman
Salad set
Transparent plastic with pewter

These two drawer pulls represent appropriate and anachronistic uses of plastics— an ever-present problem with an abundant new material.

Black and white or two colors are effective in combination.

WHAT ARE THE DESIGN ELEMENTS IN LETTERS?

1. Legibility.
This is the most important factor in any letter design. Legibility is reduced by the use of distorted, obsolete, or obscure forms.

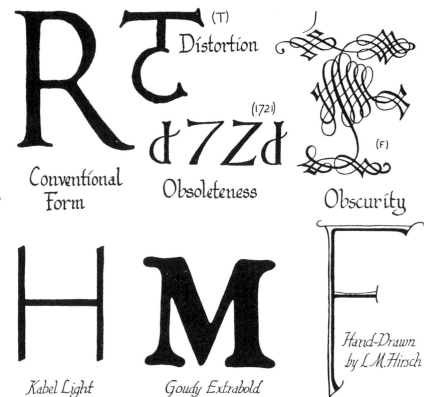

Conventional Form

(T) Distortion

(1721) Obsoleteness

(F) Obscurity

2. Variable Tone.
Great changes in effect may be had in the same letter form simply by changing the weight of its elements.

Kabel Light
Light Elements

Goudy Extrabold
Heavy Elements

Hand-Drawn by L.M.Hirsch
Open Lines

3. Adaptability to Changes in Form. Good judgment is needed to produce varied, yet legible forms.

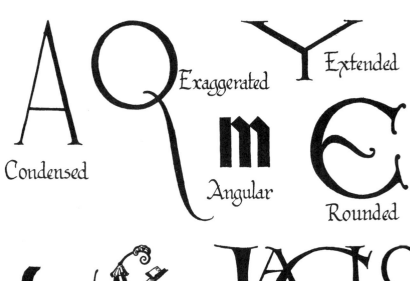

Condensed

Exaggerated

Extended

Angular

Rounded

4. Possibility of Combining in Interesting Forms. Trade marks, symbolic uses, or reduced space may call for combinations.

Monogram

Cypher

Homogram

by Graily Hewitt, Ashendene Press

~56~

WHAT FACTORS INFLUENCE LETTER DESIGN?

1. Historic Forms

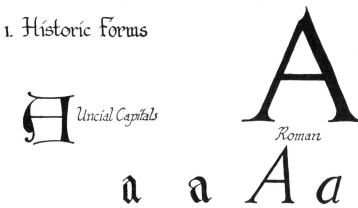

Uncial Capitals

Roman

All our letter forms are based on the Roman letter. No radical departure long survives.

Sans-Serif

Gothic Round Hand Italic Bodoni

2. Manner of Production

Calligraphic Forms

Rapidly Written with Broad Pen

Geometric Capital - Lapidary Form

Initial Letter from Fust and Schoeffer Psalter
Pen-Drawn, Built-Up Letter

Each tool used leaves a definite effect on details of letter forms.

Brush-Drawn Letters

Punch and Die Making Imposes No Certain Form on Type

3. Manner of Use

The letter, whether hand-drawn or type, may be designed for an occasion or an historic period. It may display boldness and vigor, delicacy and luxury, formality and dignity, or unconventionality.

Letters may be designed for leisurely reading, for "him who runs," or to attract and hold attention. The demands of advertising have led to a continuous line of fresh styles and variants of old ones. Appropriateness for different subjects is sought in historic style, in weight, and suggestion.

HOW ARE NEW LETTERS DERIVED?

The designer must be thoroughly familiar with all basic letter forms.

ABCDEFGHIJKLMNOPQRSTUVWXYZ

These basic forms are changed by applying a "formula" to each letter so a strong sense of unity will be present throughout the alphabet. The formula

may call for: 1. Expanding or contracting

2. Exaggerating some part

3. Changing direction or position

4. Changing the linear nature of elements making up the letter by
 a. Effects of shadow
 b. Naturalistic treatment
 c. Opening the lines
 d. Shading the elements

5. Changing the serifs

6. Imitating another technique

7. Adding a background

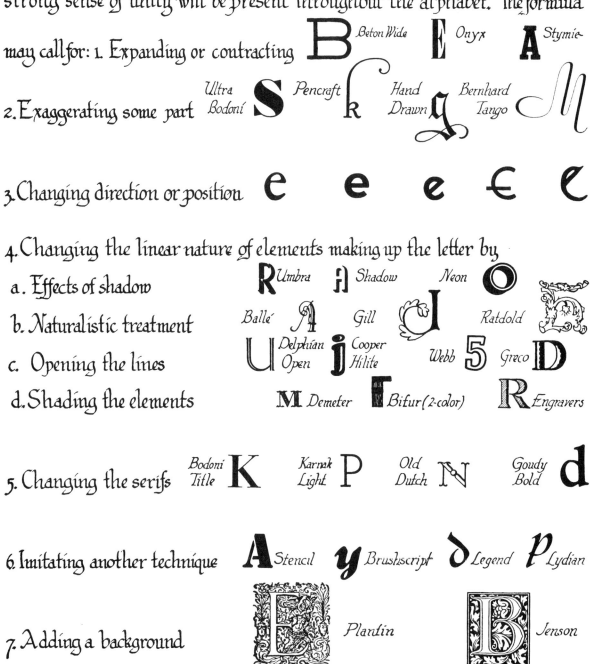

As a rule the letter forms of greatest general utility & longest favor are those departing but little from basic forms. Others may have strong but brief attractiveness.

ELEGANT

19th Century

Holy Bible

Gothic Blackletter

Historical association may influence the designer's selection of a letter, to the extent that custom must

Roman Architecture & Letters

be observed, correctness is desired, or "atmosphere" is sought. The latter usually calls for moderation.

Letter forms may, under some circumstances, be used to help suggest the thought

Stop	SO SOLLY	ADMIT ONE
STOP	**We regret**	**admit one**
STOP	WE REGRET	*Admit* one
Stop	We Regret	ADMIT ONE

The tone of voice that would be used has a degree of "carry-over" into letter forms.

Letters may reveal insincerity, a bold blatant voice, or frivolity. They may convey quiet conservativeness.

In some instances the meaning, alone, has little or no influence on letter selection.

Attitudes expressed by letter forms are, of course, largely a matter of association, hence effective only to the degree to which the reader knows and recognizes the relationship. The manner of use is equally important.

R O M A N

The roman capital frequently is letter-spaced in formal use to convey an air of dignity & permanence.

N OW, the moral side of an industry, productive or unproductive, the redeeming and ideal aspect of this bread winning, is the attainment of the highest possible skill on the part of the craftsman. Such skill, the skill of technique, is more than honesty.

Lower case letters are employed in extended passages for ease of reading.

Catherine

The black letter and most script forms are never letterspaced or used in all capital forms.

Sic dicendum
JULIUS MODES
AT VERRIUS
1 2 3 4 5 6 7 8 9 0

Caps, Lower Case, Small Caps,

1. By using type of one family or style. This does not pre~ clude the use of an occasion- al contrasting line.

Sic dicendum
MODESTUS,
AT VERRIUS
2 3 4 5 6 7 8 9 0

and Italics of Same Family

2. By tonal sympathy between type and illustration.

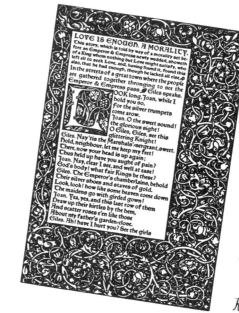

"Hypnerotomachia," Aldus, 1499

"Love Is Enough,
William Morris,
Kelmscott Press
1897

| UNIFORM

| PRINTEMPS |

| ANTIQUES |

| NEW YORK |

these *not these*

evated and clear sentiment, which may be called the de up of accumulated tra- dual pride, rendered exact

not this:

not this

This is why the atta ing of your skill wit shades of excellence ciency of a practical naturally in the stru thing beyond—a h takable touch of lov most an inspiration ish which is almost a

CAPITALS

Delights

RAGS

3. By agreement in detail and tone between type and border or ornament.

4. By the use of sim- ilar form in type mass and paper.

5. By historic correct~ ness of type & ornament.

7. By forming display material in simple and familiar shapes, usually geometric.

6. By the use of a symbolic ornament appropriate to the subject. The ornament may refer directly to the contents, or may only create an atmosphere.

It is very easy to lose unity through forcing the type into naturalistic or elaborate shapes.

8. By logical arrangement and organization of material.

Organization is secured by the clear and logical sequence in the arrangement of text in display material.

The tie-up of separated parts may be obtained by a connecting line of rule or ornament.

The connecting line may be implied by the organization of elements to provide an alignment of an edge to lead the eye from part to part.

HOW IS A REGULAR TYPE MASS BALANCED?

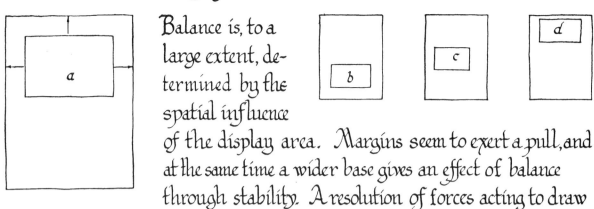

Balance is, to a large extent, determined by the spatial influence of the display area. Margins seem to exert a pull, and at the same time a wider base gives an effect of balance through stability. A resolution of forces acting to draw type mass *a* toward top and sides would bring the mass to a state of equilibrium at a point where sides are equal, and the top the same or slightly larger. Examples *b, c, and d* do not provide that resolution of forces and stability of base

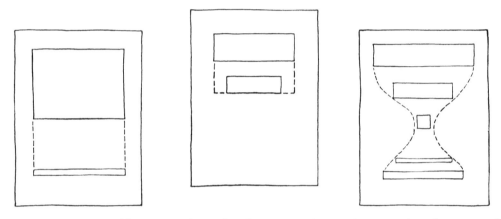

When the mass is small the pull of the base is relatively weak. When the foot is small the pull exerted by the lower margin is less than that of the other sides.

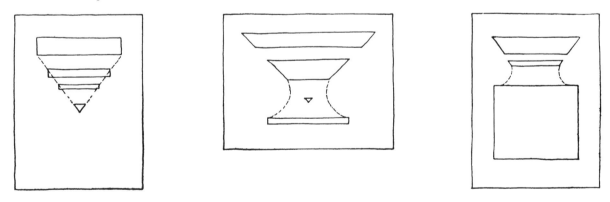

The eye tends to arrange the masses of type into an organized unit, and to seek a resolution of forces that will balance the whole on the page.

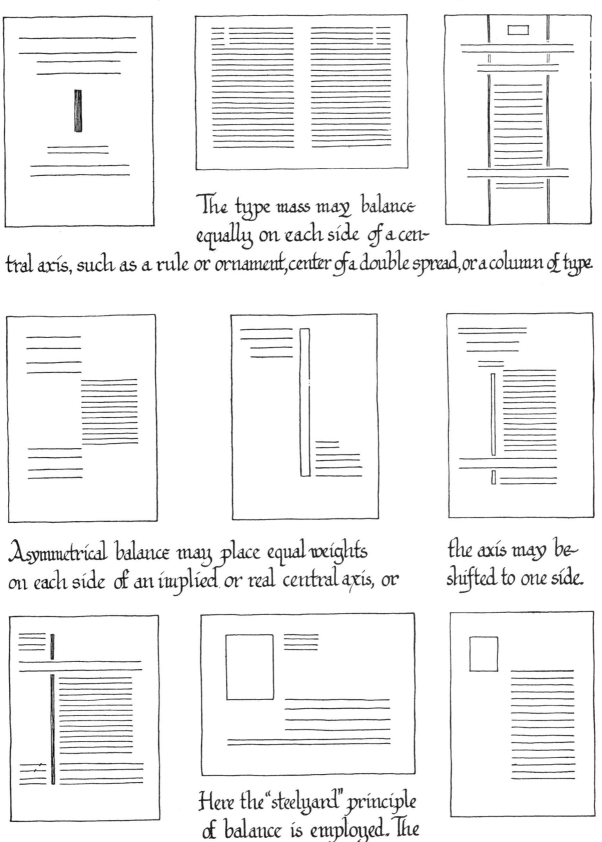

The type mass may balance equally on each side of a central axis, such as a rule or ornament, center of a double spread, or a column of type.

Asymmetrical balance may place equal weights on each side of an implied or real central axis, or the axis may be shifted to one side.

Here the "steelyard" principle of balance is employed. The axis becomes a line of motion leading the eye from one part to another.

HOW IS GOOD PROPORTION ATTAINED?

The ratio of length to width is primarily determined by content: the nature of the message, sizes and kinds of type, use, and economical cutting of stock.

The material on a ticket, for example, is most logically arranged in a horizontal form.

A poster or an announcement may take either a horizontal or a vertical form, according to the wording, and expected use.

Page proportion in a book is based on line lengths. Line length should take into account the facility of eye motion in reading. (In the common sizes of book type this length is three to four inches.) Gutter margins must be of sufficient size to permit reading to the center of the book, while outer margins should be wide enough to permit holding without covering the printing. Traditionally margins were ample to permit the scholar to make notes and commentaries on the text.

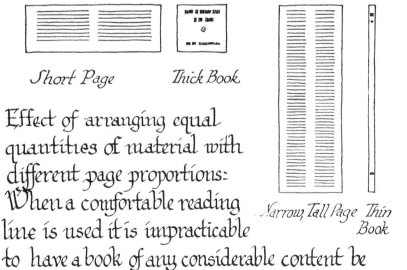

Short Page *Thick Book*

Effect of arranging equal quantities of material with different page proportions: When a comfortable reading line is used it is impracticable to have a book of any considerable content be

Narrow, Tall Page *Thin Book*

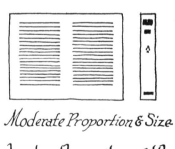

Moderate Proportion & Size

shorter than its width, hence the predomin- ance of vertical books. The ratio is one of practical value.

GOOD PROPORTION (Continued)

By tradition, as well as by function, there has come into practice a page proportion varying only slightly from 1 (width) to 1.5 (length).

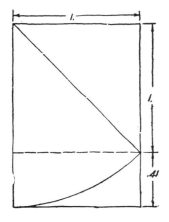 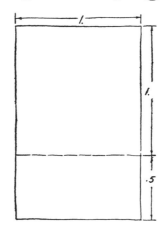 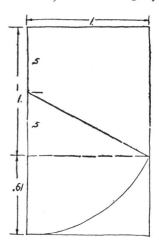

If conventional treatment is desired, proportions within these limits will usually apply, and will prove economical in cutting from standard sizes of paper.

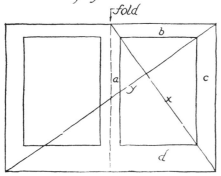

As a rule the type page is the basis of determining the proportions of the paper. In the case of a book (or program) the double page is treated as a unit. Using an over-size folded sheet, each page is drawn in position equally spaced from the fold. A diagonal (x) is drawn through the corners of the page. The point at which this line intersects the fold locates the head of the sheet. A second diagonal (y) drawn across both type pages intersects the head of the sheet and so locates a point that establishes margin c. Where this margin line crosses diagonal x fixes the point for the lower margin (d). The opposite half is, of course, an exact duplicate of the side just determined.

This method of proportioning paper size to the type page keeps the ratio between width and length of both the same, and so promotes unity.

HOW IS TYPOGRAPHY DESIGNED?

A typographic layout is the design for a piece of printing. The typographer may, under some circumstances, prefer to do his thinking directly with the type. This practice is usually less practical and economical than planning on paper. The designer must know sizes and details of the type he plans to use, and be able to letter them well.

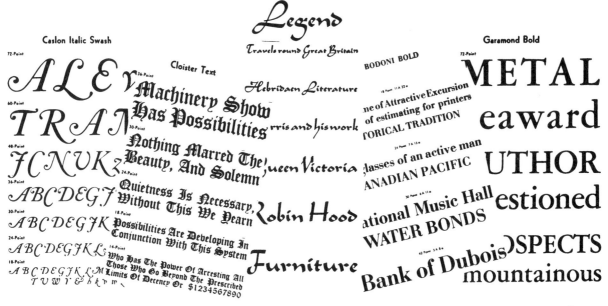

The designer will have many resources of type catalogs and display sheets.

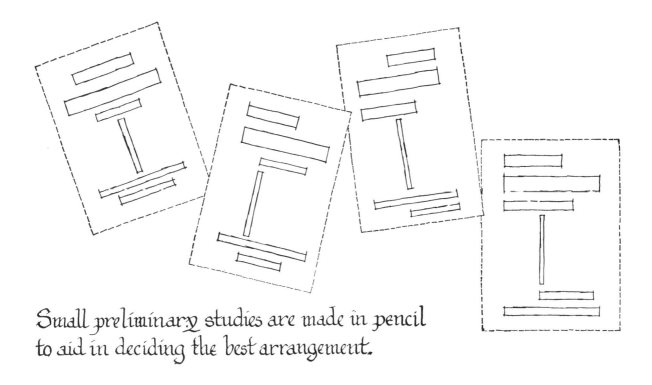

Small preliminary studies are made in pencil
to aid in deciding the best arrangement.

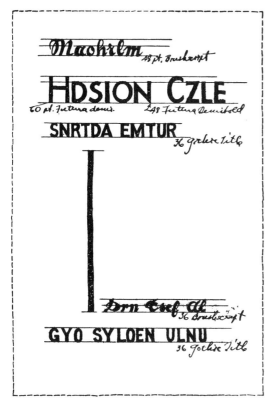

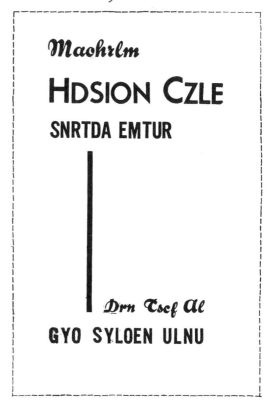

A full-size sheet is prepared, with guide lines for lettering, first sketched in place free hand, then accurately drawn to type sizes with a T-square. Lettering may be traced from the catalog and transferred to the layout, or it may be drawn freehand. Tracing paper is a good material for a layout, since letters and ornament can be sketched quickly and with accuracy by laying the sheet over the originals. Subsequent trials may develop improvements by laying each new sheet over the one most nearly right.

PICAS
1 2 3 4 5 6 7 8 9 10 12 14 16 18 20

THE PRINTER
Of The Previous

AGE PRIDED ON
Being Able To Take

RESEARCHES UNDER
The Able Direction Of

MANY FACES OF TYPE ARE
To Be Had Whether On These
Or Other Machine $1234567890

WITH VISITORS TO BE WELCOMED
and the perennial charm of early summer
entertainments some with | $1234567890

When body type is used in book or pamphlet work, the average number of characters per inch of line can be estimated from type catalogs, and an accurate calculation made of the number of lines on each page. A full dummy is then made.

DOES PAPER COUNT IN TYPOGRAPHIC DESIGN?

Paper must be selected for appropriateness to the design, as well as its adaptability to the production techniques and ultimate use.

1. Color. Sparing use is made of colored papers, except for small advertising pieces or announcements. Book papers are usually white or natural.

2. Relationship to type.

<div style="text-align: center; border: 1px dashed;">

OLD PAPERMAKING
BY
DARD HUNTER

</div>

<div style="text-align: center; border: 1px dashed;">

DEN NORSKE HUSFLIDSFORENING
GJENNEM 40 ÅR
1891–1931

</div>

Old style type tends to be rugged and vigorous. It is most effective on antique papers, especially when strongly impressed on dampened stock.

Modern type is uniform, mechanically accurate, and thus is better for the even "kiss" impression on even-surfaced, smooth papers.

3. Laid and wove. Laid paper, in particular, has much to do with the appearance of printed matter. The deckle edge of hand-made or certain machine-papers may be used on items that are to carry the effect of luxury, formality, or early historic correctness. Chain lines should run correctly for the book size.

Sheet *Folio* *Quarto* *Octavo*

4. Grain. In order to insure a flexible book, the grain should run parallel to the hinge.

5. Texture. Antique, plate, English finish, or coated paper may best fit the requirements. The designer should have many manufacturers' samples on hand. The technical requirements of printing may be the determining factor. The elimination of glare may be important, or the problem may call for planned irregularity of surface.

6. Hand- or machine-made. Cost, quantity, surface, or impression may determine choice.

WHAT FACTORS MAKE A GOOD BOOKPLATE?

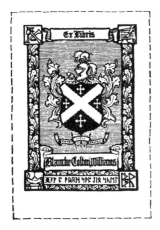

Correct details, such as heraldry

Bruce Rogers

Dignity in institutional plates

Uniqueness of design

Typographic materials used by themselves

Jaru Beran

Interesting content

Claude Bragdon

Good lettering, in an enduring style

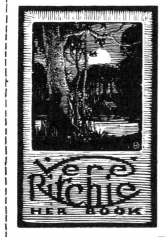

L. Roy Davies

Autographic methods of production

Rockwell Kent

Obvious symbolism

J.J. Lankes

Treatment suitable to medium employed

HOW IS A MEASURED DRAWING MADE?

Why? Research is necessary for gaining accuracy of details in historic work. Occasionally an early piece of furniture or other item must be duplicated.

Pewter Inkwell

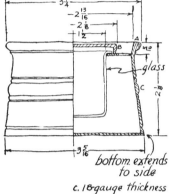

hinge

5 quill holes ⅝ spaced 60°

Where are such pieces found? In private collections, museums, and shops of dealers.

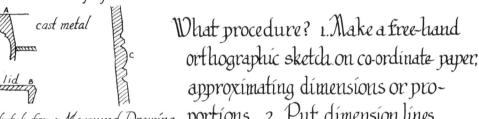

3¼
2 13/16
2⅛
1½

glass

3 5/16
bottom extends to side
c. 18 gauge thickness

cast metal

lid

Sketch for a Measured Drawing

How prepare for the drawing? 1. Get permission and have a clear understanding of what may be done. 2. Set a date. 3. Arrange equipment, including rule, tape, square, pencils, ¼ inch squared paper, tracing paper, small plumb bob, calipers, dividers, modeling wax.

What procedure? 1. Make a free-hand orthographic sketch on co-ordinate paper, approximating dimensions or proportions. 2. Put dimension lines on drawing where measurements are to be made. 3. Measure object and write dimensions on drawing. 4. Make full-size sketches of details. Letter these and key to master drawing. 5. Take wax impression of details not easily or accurately drawn. Plaster casts may be made later. 6. Make notes, freely, of color, material, finish, construction, maker, owner, date of making, reconstruction, if any. 7. Work up into finished drawing before sketches are "cold". 8. Supplement sketches with photographs, preferably professionally made. 9. Hope you have everything.

If work is published use "courtesy line" indicating ownership.

HOW IS A "MORGUE" FORMED?

A morgue is a collection of source materials assembled for its power of stimulating ideas. It consists of photographs, sketches, clippings, catalogs, samples and indexes.

Forms:

 Notes and sketches. Notebooks, separate sheets or cards kept in a file or in envelopes

 Measured drawings. Filed in portfolios or folders

 Clippings. Filed in scrapbooks, pasted in loose-leaf notebooks, pasted to index cards, or sorted into marked envelopes

 Magazine articles. Kept in large envelopes, expansion folders, mounted in scrapbooks, or attached to special gummed tabs fastened in the back of standard folders of cap size.

 Photographs. Mounted in albums, or pasted on stiff cardboard for use in a projector of the reflecting type

 Magazine illustrations. Same as for photographs

 Samples of materials, catalogs, and bulletins. Kept in boxes and library pamphlet boxes or filing cases

Sources:

 Clippings and articles. Used magazines, from private homes, or used magazine stores found in most cities (*Not from libraries*), magazine sections of the better Sunday newspapers, and special feature sections of dailies

 Photographs. Besides those obtained from private sources, great help may be had from museums, some of which have inexpensive prints in one or two sizes of every item they own.

 Catalogs. Trade magazines, household-type magazines, Wilson Index

Caution: Make excessive provision for expansion before starting to collect

PROBLEMS AND READINGS

Problems of Analysis of Requirements ⟶

Make a list of the requirements for each of the following items. Consider sizes, materials, construction, production techniques to be used, operation, place used, cost:

1. Bookcase to house set of Encyclopedia Britannica, 2. desk memo pad, 3. case for carrying drafting instruments, 4. music stand for two players, 5. coffee pot, 6. candlestick, 7. floor-type reading lamp, 8. tobacco jar, 9. leather brief-case, 10. typewriter table, 11. breakfast tray, 12. cutlery case, 13. draftsman's table, 14. earring, 15. gun cabinet, 16. T-square, 17. violin bow

Example: desk reading lamp.

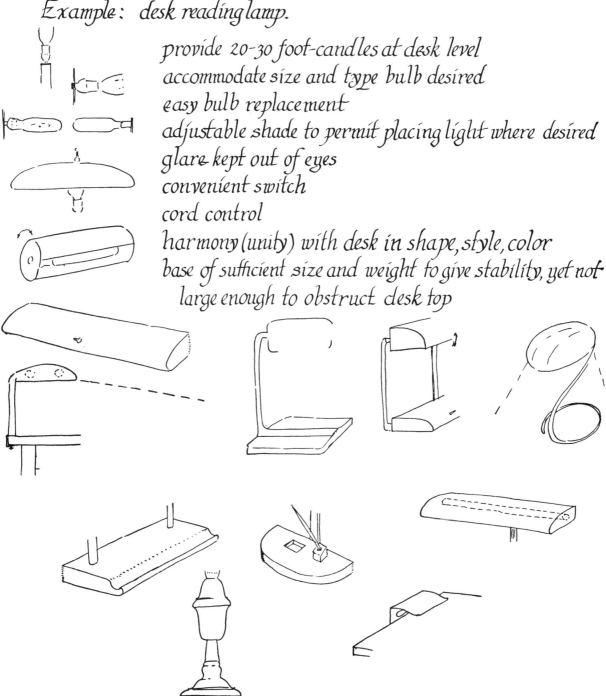

provide 20-30 foot-candles at desk level
accommodate size and type bulb desired
easy bulb replacement
adjustable shade to permit placing light where desired
glare kept out of eyes
convenient switch
cord control
harmony (unity) with desk in shape, style, color
base of sufficient size and weight to give stability, yet not large enough to obstruct desk top

Problems of Function

Analyze the mechanical function and show what is wrong with each of the following:

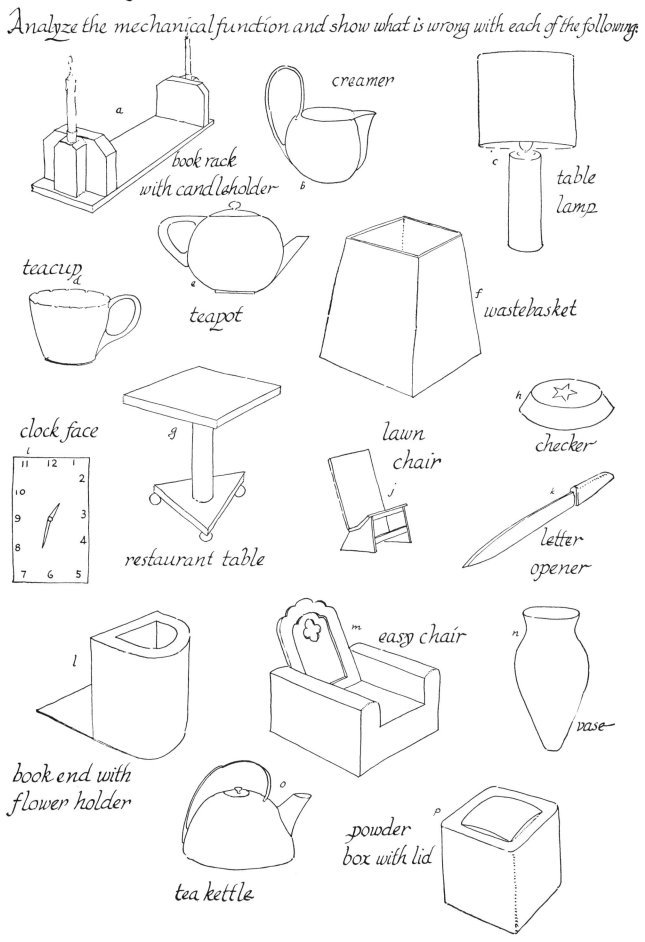

book rack
with candleholder

creamer

table
lamp

teacup

teapot

wastebasket

clock face

restaurant table

lawn
chair

checker

letter
opener

easy chair

vase

book end with
flower holder

tea kettle

powder
box with lid

Problems of Order ⁓ (harmony, organization)

1. Which handle should be selected for the creamer, to bring the greatest unity?

candy dish

2. Continue the rhythmic sequence of each of the following:

1·2·3·2·1·2————; 1·5·2·5·3·5————; 6·3·8·3·10·3·8———;10·1·9·2·8——

3. Develop an organized sequence with each of the following:

4. Arrange the following units into an organized form and repeat to make a band.

Elements examples

5. Organize the following elements into an all-over pattern.

6. Devise units that will harmonize with each of the following:

Problems in Balance — (proportion)

Correct the balance fault in each of the following:

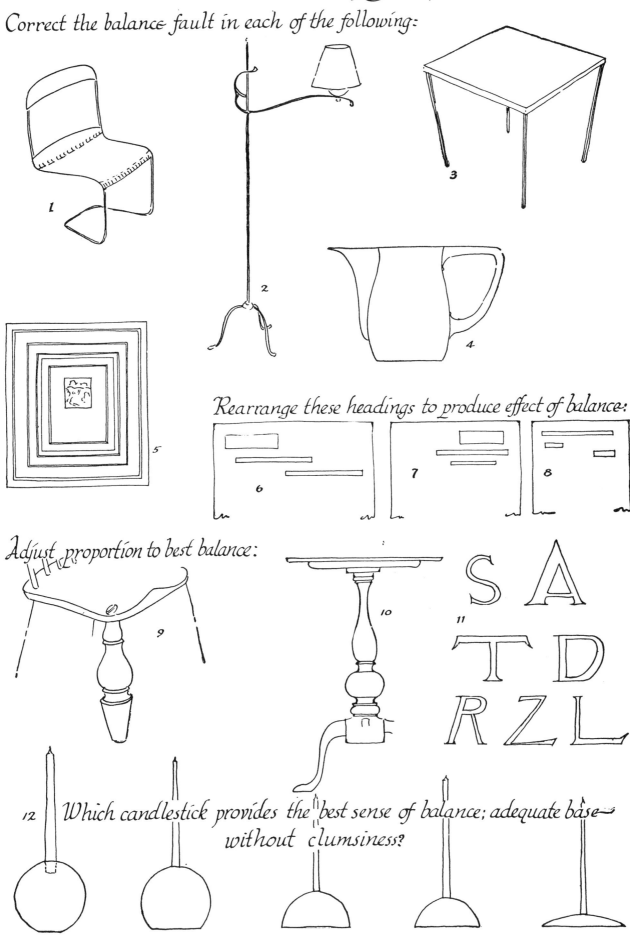

Rearrange these headings to produce effect of balance:

Adjust proportion to best balance:

SATD RZL

12 | Which candlestick provides the best sense of balance; adequate base without clumsiness?

Problems in Geometric Form ⸺.

1. Draw circles, then, with the compass set at the radius, and at the diameter, try out the many variations that can be made with one or two diameters.

2. After drawing the outside circle, set the compass to other radii, and try to organize circles and arcs within the circumference.

4. Borders should be developed with circles and arcs alone, then in combination with straight lines. These should be suitable for carving, ceramics, or casting in soft metal.

3. Try numerous all-over pattern with circles and arcs.

5. Draw a gothic arch, such as could be used for a carved book end.

6. Draw a trefoil, a quatrefoil. See Meyer, Handbook, p 18-19.

7. Plan the repeat for a chip-carved box. See Mankin, Modernistic Chip Carving.

8. Draw a geometric band. See Meyer, plate 86.

9. Draw a geometric pattern for a circular silver brooch with contrasting overlay.

10. Design the links of a bracelet, using Pennsylvania-Dutch barn symbols in color.

11. Plan a circular arrangement for the pierced holes in a tea strainer.

Problems in the Use of Free-hand Curves ~

1. Practice on the blackboard or large sheets of paper, using full-arm action. Make single unit curves, working from all directions. Use chalk or soft crayon.

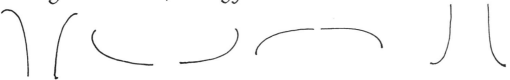

2. Do the same exercise on a sheet of paper 9x12.

3. Repeat, using smaller lines and employing finger action, only.

4. Draw units like the following, and add one more element to each, observing first a contrast, then a continuity.

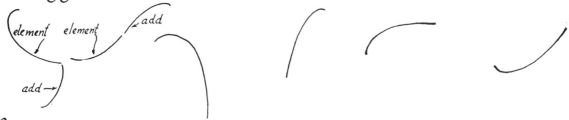

5. Add one element to each of the following, using a break of some sort between the part given and the added element.

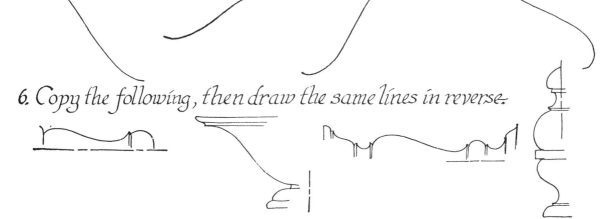

6. Copy the following, then draw the same lines in reverse.

7. Complete the following bases:

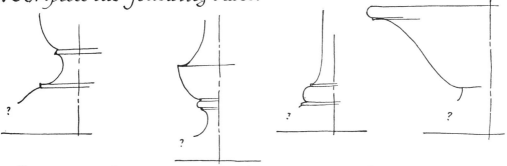

8. Draw a volute on the blackboard, then repeat as in exercises 2&3 above.

9. Try to copy the volute from an Ionic capital.

Problems in Wrought Iron

Cut from flat iron:

1. Lock escutcheon plate for pine or walnut chest.
2. Strap hinges for same.
3. Stag-horn hinge for a heavy door.
4. Silhouette on fire screen for fireplace in summer cabin.
5. Escutcheon plate for door of a hunting lodge.
6. Road sign for a dairy.
7. Weather vane for a garage with towing service.
8. Sign for a tea-room in the home of a Revolutionary war hero.
9. Wall sconces for an athletic field house dining room, each to represent a sport.
10. Sign for a post in front of a rural doctor's office.

To be forged from round or square stock:
11. Long latch for a gate.
12. Strap hinges for same.
13. Hinges for a heavy door.
14. Floor lamp with tapered shaft and adjustable arm.
15. Reading lamp for study table.
16. Andirons for fireplace in men's browsing room of a library.
17. Seven-branched candlestick.
18. Footscraper for colonial home.
19. Fork for roasting apples.
20. Suffolk latch. (Sonn)
21. Bracket for ivy bowl.
22. Knocker and plate.
23. Fireplace equipment, including poker, tongs, and shovel.
24. Shutter catches.

Problems in Thin-Gauge Metals

1. Design handles or knobs for the following:

2. Complete the top.

3. Design a fruit bowl to match.

4. Design creamer and sugar bowl to match.

5. Design a flower bowl to match.

Design: 6. Stainless steel pie-server with wooden or plastic handle.

7. Desk set in pewter or copper, using some occupational symbol.

8. Wall light, using the hinge as a motif.

9. Same, using the key plate.

10. Cut patterns from paper for Christmas tree ornaments, then cut from brass.

11. Key plate for a Chippendale chest lock. (Originals were cast.)

12. Silver presentation case for a medal.

13. Silver punch bowl for a formal Georgian room.

14. Pewter flower bowl with flat sides.

15. A baby's first mug, of silver.

16. Individual communion set in velvet-lined carrying case.

17. Post lamp for a country home.

18. Queen Anne pewter teapot to hold six cups.

19. Candle stick with saucer base.

20. Flower holder with reeded sides.

21. Crumb tray to match some selected silver pattern.

22. Clock face with modern style etched figures.

23. Compact with enamel decoration.

24. Engraved case for gift pen and pencil set.

25. Humidor with decoration in a second metal in contrasting color.

Problems in Cast Metal.—

Sketch designs for the following. Work up final plan with charcoal or ink wash:

1. Name plate for a desk, to be cast in type metal.
2. Plate for a sun dial, to be cast in lead.
3. Bronze plate for a memorial tree or flag pole.
4. Key for an honor society.
5. Door knocker to be cast in brass.
6. Holder for a meat carving set - type metal.
7. Holder for a single pipe.
8. Letter opener - pewter handle on steel blade.
9. Silver mounting for a cork on a perfume bottle.
10. Small baluster-type pewter candle stick.
11. Paper weight to be cast in pewter.
12. Brass key, using a fraternal symbol as a motif for the handle.
13. Pewter plaque commemorating a tour by a musical organization.
14. Handle for a brass seal to imprint wax on letters.
15. Handle for a pewter beaker.
17. Wall light, using vase-type turning for the back. Arm of brass, plated.

Sketch, then model in clay, wax, or plasticine:

18. Pewter buttons for woman's sport suit.
19. School emblem to be cast in aluminum.
20. Class ring or pin.
22. Handle for a traditional porringer.
23. Same, using a monogram, cipher, or initial as the motif.
24. Knob for a humidor, using the tobacco leaf as the motif.
25. Mould in which special shapes of candles may be cast.
26. Napkin ring for a child, cast in pewter with suitable symbolism.
27. Pendant for a bookmark, using book symbol.
28. Plate for a door bell, to harmonize with selected architectural style.
29. Brass handles for fireplace set.
30. Small portrait frame for home desk.
31. Scout neckerchief slide.
32. Salt and pepper shakers for slush casting production.

Problems in Wood

1. Study the processes of cutting wood, including the lathe.
2. Collect samples of various woods. List suitable uses of each.
3. Learn ways of joining wood, and appropriate uses of each kind of joint.
4. Find out what woods are appropriate for each major historic style.
5. Examine carving tools. Make test cuts with each. Sketch the results.
6. Try out chip carving. Make a sampler of cuts. Lay out geometric patterns.

Design the following:

7. Sign for an office or shop. Letters may be carved into the wood, or raised above the surface.
8. Bread board with inscription carved in a band around the rim.
9. Clock face with sans-serif figures, carved and colored.
10. Wooden pipe, using figurine similar to stone pipes of Ohio mound builders
11. Fruit bowl. Plan to let tool marks show without sanding.
12. Base for a selected piece of pottery or ceramic sculpture.
13. Case for a presentation baton for a music director.
14. Gatepost finial. (See book of Salem architecture.)
15. Stamp box with appropriate low-relief carving.
16. Carved case for individual communion set.
17. Chip carved case for chess or checkers set.
18. Brass stamps to be cut from $\frac{1}{4}$" rod, to be used for stamping low background.
19. Hanging sign for a roadside inn at a historic location.
20. Gate for an informal garden. Same for kennel for thorough-bred dogs.
21. Gardener's case for carrying tools, kneeling pad, seeds, etc.
22. Rack to hold croquet set.
23. Bird feeding station.
24. Box to hold draftsman's equipment.
25. Case for manicure equipment and supplies.
26. Hanging shelf to fit following specifications:
27. Stand to hold phonograph pick-up, with album space.
28. Salesroom pedestal to display piece of fine glass. (Light from beneath)

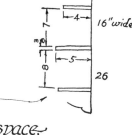

Problems in Wood—

29. Clothes tree to induce child to hang up his clothes.
30. Music stand for a string quartet. (Jefferson did it!)
31. Wooden handle for silver or pewter sauce pan. Lay out pattern on folded paper and cut out with scissors. Repeat until result is right.
32. Shaft and base for low desk light.
33. Chair leg in Jacobean style; same in William and Mary.
34. Make series of free-hand sketches of feet and legs of various historic styles.
35. Front round of good Windsor or ladder-back chair.
36. Wooden gavel.
37. Fireside stool with turned legs and stretcher.
38. Pattern for Queen Anne chair leg.
39. Small chest for silver ware – bun feet.
40. Stand, with circular top, turned shaft, and snake foot.
41. Ladder-back chair.
42. Various types of Sheraton and Hepplewhite chair backs.
43. Chippendale mirror.
44. Phyfe table leg. Lyre card table support.
45. Drawing table to be put in room of Jacobean furniture.
46. Radio cabinet to fit into a room of Phyfe furniture.
47. Examine structure of the modern chair. (Saarinen, et al.)
48. Sketch essentials of Swedish modern.
49. Design an office desk to harmonize with a Frank Lloyd Wright house.
50. Plan a cabinet to house radio, phonograph, and television.

Problems in Ceramics ～

1. Copy and design a handle for each of the following:

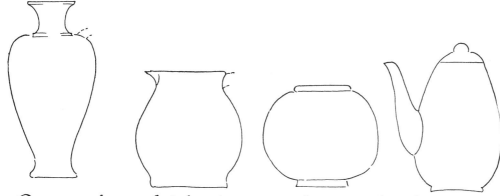

2. Copy and complete by drawing a base to the dotted line:

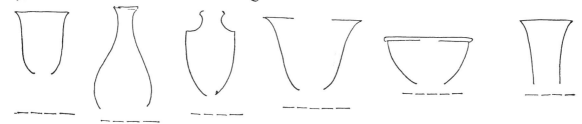

3. Design a bowl or vase for the following: a. long-stemmed yellow roses, b. violets, c. bittersweet vine cluster, c. gladiolas, d. mixed bouquet.

4. Design a square tile with a conventionalized flower covering the surface in intaglio.

5. Copy a number of Pennsylvania German scraffito decorative motifs. Adapt one of these to a lamp base, a cookie jar, a jam pot, a candlestick.

6. Draw and color a set of tiles for the floor of a library, using printers' marks as decoration.

7. Plan a low bowl to hold a triangular candle and flower holder.

8. Design a cheese plate for the center of a wooden serving tray.

9. Develop the pattern for a rectangular "pillow vase" with a moulding foot.

10. Try to copy the lines of a Chinese vase.

11. Much pottery is based on simple geometric solids or combinations thereof. Plan several pieces around these forms.

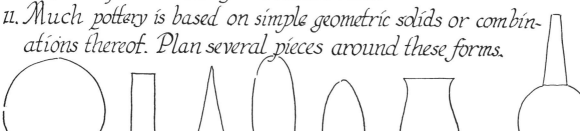

Problems in Leather—

1. Select one or more suitable leathers for the following: man's belt, book cover, woman's purse, writing desk pad, waste basket, glasses case, key case.

2. Select leathers that have distinct natural surface pattern.

3. Select leathers suitable for tooling.

4. Try several ways of lacing. Draw a short section of each.

5. Make a collection of snaps, buttons, etc, for use on leather.

6. Design a brass stamp, such as is used by the bookbinder, for impressing leather.

7. Draw a monogram or cypher to be cut in linoleum for impressing leather. Try to produce the effect of interlacing bands.

8. Produce an alphabet suitable for modeling in leather with a single stroke.

9. Design a portfolio with an inscription running around the border.

10. Same for a wallet, a brief case, a purse, a book cover.

11. Plan materials, accessories, sizes, fastenings, decoration, and lay out the pattern for the following: bag tag, traveling clock case, scout knife case, music stand case, wrist watch band, notebook cover, playing card case, bow guard (archery), quiver, camera case, pocket photo case—

12. Study the following decorative techniques and design some piece of work with each: modeling, tooling, gold tooling, coloring, inlaying, carving, stamping background, lacing in various styles. Keep decoration simple, meaningful, and reduced to the minimum. (Much modern leather decoration hides the beauty of the material and is more appropriate for a Mexican saddle than anything else.)

Problems in Textiles

1. Collect manufacturers' sample cards of warp and weft materials. These should show sizes and color ranges.
2. Study the mechanism and weaving action of various basic looms.
3. Gather and mount samples of various weaves, materials, and patterns.
4. After working out the structure of a warp-faced fabric woven on a belt loom, design a pattern and test by weaving a portion. Use two colors.
5. Draw a pattern for a small table mat with a simple inlaid geometric center. Render in two colors of crayon.
6. Plan a bag with a zipper top, to be woven over a card, using a conventionalized flower inlaid (tapestry weave) in one side.
7. Design a chair pad to be woven in heavy wool, with a pattern in the manner of a Navajo saddle blanket.
8. Design a scarf, using stripes of color in the warp. When rendering, observe the color effects where weft colors cross warp colors.
9. Copy the draft of the honeysuckle pattern on the top of a sheet of squared paper. Below this make a number of weaving variations.
10. Repeat, using two colors of weft.
11. Design a draft for a plain twill. For a herringbone.
12. Design a table runner, using stripes of color in the warp, and woven in twill with two colors of weft.
13. Plan a bookmark, woven of fine thread, having rectangular blocks of color.
14. Analyze a simple four-harness pattern and draft to pick out the pattern repeat. Lay out a draft to use the repeat several times.
15. Same as above, but select some suitable part of the draft to use as a border, with a repeat on the opposite side, possibly in reverse.
16. Design a geometric hooked rug. Select the colors.
17. Same with a conventionalized pattern; a naturalistic pattern.
18. Design a repeating ornament for blockprinting the curtains for a music room; a sun room; a study.
19. Adapt a Grecian or Roman border pattern to a silk screen technique.
20. Draw several sports figures, in simplified form, to be printed on summer dress goods by blocks or silk screen.

Problems in Graphic Arts

1. Collect display sheets of type styles.
2. Start a scrap book of examples of pen lettering used in ads, book jackets, and magazine titles.
3. Organize a morgue of letterheads, business cards, progams, tickets, etc.
4. Draw a few capitals and lower case letters of Goudy Forum Title, Missall, Cloister Blackletter, Caslon Italic, Bodoni, Kabel, Neuland, Trafton.

In the following examples lay out the border of the card or sheet to be designed, then cut strips of grey paper of actual type height (not body size) and move them about on the bordered sheet until a satisfactory arrangement is secured. Then letter in the actual words in place of the strips of paper.

5. Business card.

a. Name / Address / Phone

b. Firm / Address / Product / Phone

c. Firm / Product / Address / Phone / Representative

6. Letterhead

$8\frac{1}{2} \times 11$, $8 \times 10\frac{1}{2}$

Asymmetrical balance

Symmetrical balance

a. Name / Address

b. Name / Address / Symbol

c. Name / Address

d. Name / Product / Address / President

e. Name / Address / Symbol

f. Organization / Address / Officers / Symbol

7. Ticket

Symmetrical

a. Event / where / When / Price

b. Admit one / Event / By whom / when / where / Price

Asymmetrical

c. Event / where / when / Admit one / Description / Price

Problems in Graphic Arts

8. Covers for booklets and programs, title pages, advertisements

Change sizes or ratios as desired. Subjects should be varied, with corresponding changes made in illustrations and other lines. Try each problem with several styles of type.

Symmetrical

a
| Title | | Author |

| Publisher |

b
| Title | | Title |

▽ Ornament | Institution |

c.
| Illustration |

| Title |
| Sub-title |
| Author |
| Place |

d
| Title | | Title | | Ornament |

—Description—

| Publisher |
| Place |

Asymmetrical (extra connecting lines may be added to the following)

e
| Title |
| Sub-title |
| Author |
—Publisher—
—Place—

f
| Symbol |

| Title |
| Author |
Description
—Publisher—

—Type—

| Illus. |

9. Re-design the material from a symmetrical pamphlet cover into an asymmetrical design.
10. Re-design an advertisement from an old magazine, using modern type.
11. Design a full alphabet to match the following: A A A A A A A A
12. Design a letter (caps) to be cut in linoleum or wood, showing toolmarks.
13. Design a typographic bookplate to be used by an institution.
14. Design a woodcut bookplate for a special collection of books on a field, such as bookmaking, ancient tools, music, American history.
15. Design a bookplate for a child, using a nursery story character.
16. Plan the layout for the front page of a school newspaper.

Problems in Plastics ～

1. Collect samples of types and colors of plastics. Secure data on light-fastness and other qualities.
2. Try methods of joining, bending, cutting, polishing, coloring, & engraving.
3. Design some object for whose use a plastic is superior to the original material. (This idea can frequently be reversed.)
4. Design an article in which a plastic makes possible a new use or a new product.

Design the following:

5. Paper weight from a block of plastic.
6. Base for desk memo pad.
7. Candy box; jewel box; box with compartments for desk supplies.
8. Hall light, utilizing the quality of conducting light.
9. Restaurant tray for quantity production; serving tray for home use.
10. Curtain pull.
11. Desk holder for ink bottle and pen; for india ink bottle.
12. Ornamental buttons.
13. Monogrammed device for end of a ribbon book mark.
14. Holder for stems of flowers to be displayed in a shallow bowl.
15. Handles for a desk of modern design made of light-colored wood.
16. Grip handles for a carving set.
17. Coasters with engraved ornament on under-side.
18. Candlestick to hold large Christmas candle, utilizing the candle flame to illuminate the holder.

Ornament

* Blossfeldt, Karl. *Art Forms in Nature.* New York: Weyhe.
* Bossert, H. T. *Ornament in Applied Art.* New York: Weyhe.
 — *Volkskunst in Europa.* Berlin: Ernst Wasmuth.
Bragdon, Claude. *Projective Ornament.* New York: Knopf.
Cole, H. *Heraldry and Floral Forms in Decoration.* London: E. P. Dutton & Co.
Crane, Walter. *The Bases of Design.* London: Bell.
Hamlin, A. D. F. *A History of Ornament.* New York: The Century Co.
* Meyer, Franz. *A Handbook of Ornament.* New York: Architectural Book Publishing Co.
* Speltz, Alexander. *Styles of Ornament.* New York: Grosset and Dunlap.

American: General

Eaton, Allen. *Handicrafts of the Southern Highlands.* New York: Russell Sage Found'n.
Halsey, R. T. H., and Tower, Elizabeth. *Homes of Our Ancestors.* Garden City: Doubleday.
Kauffman, Henry. *Pennsylvania Dutch: American Folk Art.* New York: American Studio.
* Kimball, Fisk. *Domestic Architecture of the American Colonies and Early Republic.*
 New York: Scribners.
Valliant, George C. *Indian Arts in North America.* New York: Harper and Brothers.
W. P. A. Writers' Project. *Hands That Built New Hampshire.* Brattleboro: Stephen Day Press.
Worcester Art Museum. *Contemporary New England Handicrafts.*
 Worcester, Massachusetts: The Museum.

Foreign: General

Felice, Carlo. *Arti Industriale d'Oggi.* Milan: Lugio.
Holme, Charles. (ed) *Peasant Art in Austria.* London: The Studio, Ltd.
 — *Peasant Art in Italy.* Studio.
 — *Peasant Art in Russia.* Studio.
 — *Peasant Art in Sweden, Lapland, and Iceland.* Studio.
Lemos, Pedro. *Guatemala Art Crafts.* Worcester: Davis Press.
Stavenow, Åke. *Swedish Modern.* New York: Royal Swedish Commission.
Sterner, Maj. *Homecrafts in Sweden.* Leigh-on-Sea: F. Lewis, The Tithe House.
Toor, Frances. *Mexican Popular Arts.* Mexico, D. F.: Frances Toor Studios.

* Available as a Dover reprint.

Metal

Adair, John. *Navajo and Pueblo Silversmiths.* Norman: Univ. of Oklahoma Press.

Avery, C. Louise. *Early American Silver.* New York: D. Appleton-Century Co.

Davidson, P. W. *Applied Design in the Precious Metals.* London: Longmans, Green & Co.

Griswold, Lester. *Handicraft.* Colorado Springs: Pub. by the Author.

Hayward, Arthur. *Colonial Lighting.* Boston: B. J. Brimmer Co.

Keerling, Gerald K. *Wrought Iron in Architecture.* New York: Charles Scribner's Sons.

Kerfoot, John B. *American Pewter.* Boston: Houghton Mifflin Co.

Kronquist, Emil. *Metalcraft and Jewelry.* Peoria: Manual Arts Press.

Laughlin, Ledlie. *Pewter in America.* Boston: Houghton Mifflin Co.

Maryou, Herbert. *Metalwork and Enamelling.* London: Chapman & Hall, Ltd.

Osburn, Burl and Wilber, Gordon: *Pewter: Spun, Wrought and Cast.* Scranton: International Textbook Co.

Pack, Greta. *Jewelry and Enameling.* New York: D. Van Nostrand.

Rose, Augustus, and Cirano, Antonio. *Jewelry Making and Design.* Providence: Metal Crafts Publishing Co.

Sonn, Albert. *Early American Wrought Iron.* New York: Charles Scribner's Sons.

Wethered, Newton. *Mediaeval Craftsmanship and the Modern Amateur.* [vitreous enamel] New York: Longmans Green & Co.

Leather

Bang, E. E. *Leathercraft for Amateurs.* Boston: The Beacon Press.

Griswold, Lester. *Handicraft.* [the author] Colorado Springs.

Leland, Charles. *Leather Work.* London: Sir Isaac Pitman Sons, Ltd.

Ceramics

Barber, Edwin A. *Tulipware of the Pennsylvania German Potters.* Philadelphia: Patterson & White Co.

Binns, C. F. *The Potter's Craft.* New York: D. Van Nostrand Co.

Cox, Warren E. *The Book of Pottery and Porcelain.* New York: L. Lee and Shepard Co.

Dougherty, John W. *Pottery Made Easy.* Milwaukee: Bruce Publishing Co.

Spargo, John. *Early American Pottery and China.* New York: The Century Co.

Whall, C. W. *Stained Glass Work.* London: Sir Isaac Pitman & Sons, Ltd.

Wood

* Andrews, Edward and Faith. *Shaker Furniture.* Yale University Press.
Burr, Grace. *Hispanic Furniture.* New York: Hispanic Society.
Cescinsky, H., and Hunter, G.L. *English and American Furniture.* New York: Garden City Publishing Co.
Clifford, C.R. *Period Furnishings.* Clifford and Lawton.
Dyer, Walter. *Creators of Decorative Styles.* Garden City: Doubleday Page & Co.
—— *Handbook of Furniture Styles.* New York: The Century Co.
Gottshall, Franklin. *How to Design Period Furniture.* Milwaukee: Bruce Pub. Co.
—— and Helum, Amanda. *You Can Whittle and Carve.* Bruce Pub. Co.
Hayden, Arthur. *Furniture Designs of Chippendale, Sheraton, and Hepplewhite.* McBride
Hunt, W. Ben. *Whittling Book.* Milwaukee: Bruce Publishing Co.
Macquoid, Percy, and Edwards, Ralph. *Dictionary of English Furniture.* 2v. New York: Charles Scribner's Sons.
Mankin, Vic. *Modernistic Chip Carving.* Milwaukee: Bruce Publishing Co.
Nutting, Wallace. *Furniture Treasury.* 3v. Framingham: Old America Co.
Nye, Alvan C. *Furniture Designing and Drafting.* New York: W.T. Comstock.
Osburn, Burl and Bernice. *Measured Drawings of Early American Furniture.* Bruce.
Salomonski, Verna C. *Masterpieces of Furniture Design.* Grand Rapids: Periodical Publishing Co.

Textiles

Amsden, Charles. *Navajo Weaving.* Santa Ana: The Fine Arts Press.
Atwater, Mary M. *The Shuttlecraft Book of American Handweaving.* New York: Macmillan Co.
Baity, Elizabeth. *Man Is a Weaver.* Viking Press.
Baker, W.D., and I.S. *Batik and Other Pattern Dyeing.* Chicago: Atkinson, Mentzer & Co.
Christie, Grace. *Embroidery and Tapestry. Weaving.* London: J. Hogg.
Clouzot, Henri. *Painted and Printed Fabrics.* New York: Metropolitan Museum of Art.
Corbin, T.J. *Hand-block Printing on Textiles.* London: Sir Isaac Pitman and Sons, Ltd.
Davison, Marguerite P. *A Handweaver's Pattern Book.* Swarthmore, Penna.: The Author.
Hooper, Luther. *Weaving with Small Appliances.* New York: Pitman.
Kent, William. *The Hooked Rug.* New York: Dodd, Mead & Co.
Marshall, H.G. *British Textile Designers Today.* Leigh-on-Sea: F. Lewis, Ltd.
Reeve, Nancy. *Weaves of Handloom Fabrics.* Philadelphia: Pennsylvania Museum of Art.
Worst, Edward. *Footpower Loom Weaving.* Milwaukee: Bruce Publishing Co.

Graphic Arts

* Cockerell, Douglas. *Bookbinding and the Care of Books.* New York: D. Appleton Co.

French, et al. *Bookbinding in America.* Southwick-Anthoensen Press.

Hunter, Dard. *Papermaking through Eighteen Centuries.* New York: Wm. Rudge.

Loring, R.B. *Decorated Book Papers.* Cambridge: Harvard College Library.

Arms, John Taylor. *Handbook of Print Making.* New York: Macmillan Co.

Hiett, H.L. *Silk Screen Production.* Cincinnati: Signs of the Times Pub. Co.

De Lopetecki, Eugene. *Advertising Layout and Typography.* New York: Ronald Press.

Dwiggins. W.A. *Layout in Advertising.* New York: Harper and Brothers.

Ehrlich, Frederick. *The New Typography and Modern Layouts.* New York: Stokes.

Friend, Leon and Hefter, Joseph. *Graphic Design.* New York: McGraw-Hill.

Goudy, Fred. *Design and Beauty in Printing.* New York: Press of the Wooly Whale.

Les Artes del Libro en Los Estados Unidos, 1931-1941. Nueva York: Instituto Norte-americano Artes Gráficas.

Goudy, Fred. *The Alphabet and Elements of Lettering.* Berkeley: Univ. of California Press.

Holme, C.J (ed.) *Lettering Today.* London: Studio.

Johnston, Edward. *Writing. Illuminating and Lettering.* London. Sir Isaac Pitman & Sons.

Ogg, Oscar. *An Alphabet Source Book.* New York: Harper and Brothers.

Updike, Daniel B. *Printing Types.* Cambridge: Harvard University Press.

* Available as a Dover reprint.

A CATALOG OF SELECTED

DOVER BOOKS

IN ALL FIELDS OF INTEREST

A CATALOG OF SELECTED DOVER
BOOKS IN ALL FIELDS OF INTEREST

100 BEST-LOVED POEMS, Edited by Philip Smith. "The Passionate Shepherd to His Love," "Shall I compare thee to a summer's day?" "Death, be not proud," "The Raven," "The Road Not Taken," plus works by Blake, Wordsworth, Byron, Shelley, Keats, many others. 96pp. 5³⁄₁₆ x 8¼. 0-486-28553-7

100 SMALL HOUSES OF THE THIRTIES, Brown-Blodgett Company. Exterior photographs and floor plans for 100 charming structures. Illustrations of models accompanied by descriptions of interiors, color schemes, closet space, and other amenities. 200 illustrations. 112pp. 8⅜ x 11. 0-486-44131-8

1000 TURN-OF-THE-CENTURY HOUSES: With Illustrations and Floor Plans, Herbert C. Chivers. Reproduced from a rare edition, this showcase of homes ranges from cottages and bungalows to sprawling mansions. Each house is meticulously illustrated and accompanied by complete floor plans. 256pp. 9⅜ x 12¼.
0-486-45596-3

101 GREAT AMERICAN POEMS, Edited by The American Poetry & Literacy Project. Rich treasury of verse from the 19th and 20th centuries includes works by Edgar Allan Poe, Robert Frost, Walt Whitman, Langston Hughes, Emily Dickinson, T. S. Eliot, other notables. 96pp. 5³⁄₁₆ x 8¼. 0-486-40158-8

101 GREAT SAMURAI PRINTS, Utagawa Kuniyoshi. Kuniyoshi was a master of the warrior woodblock print — and these 18th-century illustrations represent the pinnacle of his craft. Full-color portraits of renowned Japanese samurais pulse with movement, passion, and remarkably fine detail. 112pp. 8⅜ x 11. 0-486-46523-3

ABC OF BALLET, Janet Grosser. Clearly worded, abundantly illustrated little guide defines basic ballet-related terms: arabesque, battement, pas de chat, relevé, sissonne, many others. Pronunciation guide included. Excellent primer. 48pp. 4³⁄₁₆ x 5¾.
0-486-40871-X

ACCESSORIES OF DRESS: An Illustrated Encyclopedia, Katherine Lester and Bess Viola Oerke. Illustrations of hats, veils, wigs, cravats, shawls, shoes, gloves, and other accessories enhance an engaging commentary that reveals the humor and charm of the many-sided story of accessorized apparel. 644 figures and 59 plates. 608pp. 6 ⅛ x 9¼.
0-486-43378-1

ADVENTURES OF HUCKLEBERRY FINN, Mark Twain. Join Huck and Jim as their boyhood adventures along the Mississippi River lead them into a world of excitement, danger, and self-discovery. Humorous narrative, lyrical descriptions of the Mississippi valley, and memorable characters. 224pp. 5³⁄₁₆ x 8¼. 0-486-28061-6

ALICE STARMORE'S BOOK OF FAIR ISLE KNITTING, Alice Starmore. A noted designer from the region of Scotland's Fair Isle explores the history and techniques of this distinctive, stranded-color knitting style and provides copious illustrated instructions for 14 original knitwear designs. 208pp. 8⅜ x 10⅞. 0-486-47218-3

Browse over 9,000 books at www.doverpublications.com

ALICE'S ADVENTURES IN WONDERLAND, Lewis Carroll. Beloved classic about a little girl lost in a topsy-turvy land and her encounters with the White Rabbit, March Hare, Mad Hatter, Cheshire Cat, and other delightfully improbable characters. 42 illustrations by Sir John Tenniel. 96pp. 5³⁄₁₆ x 8¼. 0-486-27543-4

AMERICA'S LIGHTHOUSES: An Illustrated History, Francis Ross Holland. Profusely illustrated fact-filled survey of American lighthouses since 1716. Over 200 stations — East, Gulf, and West coasts, Great Lakes, Hawaii, Alaska, Puerto Rico, the Virgin Islands, and the Mississippi and St. Lawrence Rivers. 240pp. 8 x 10¾.
0-486-25576-X

AN ENCYCLOPEDIA OF THE VIOLIN, Alberto Bachmann. Translated by Frederick H. Martens. Introduction by Eugene Ysaye. First published in 1925, this renowned reference remains unsurpassed as a source of essential information, from construction and evolution to repertoire and technique. Includes a glossary and 73 illustrations. 496pp. 6⅛ x 9¼. 0-486-46618-3

ANIMALS: 1,419 Copyright-Free Illustrations of Mammals, Birds, Fish, Insects, etc., Selected by Jim Harter. Selected for its visual impact and ease of use, this outstanding collection of wood engravings presents over 1,000 species of animals in extremely lifelike poses. Includes mammals, birds, reptiles, amphibians, fish, insects, and other invertebrates. 284pp. 9 x 12. 0-486-23766-4

THE ANNALS, Tacitus. Translated by Alfred John Church and William Jackson Brodribb. This vital chronicle of Imperial Rome, written by the era's great historian, spans A.D. 14-68 and paints incisive psychological portraits of major figures, from Tiberius to Nero. 416pp. 5³⁄₁₆ x 8¼. 0-486-45236-0

ANTIGONE, Sophocles. Filled with passionate speeches and sensitive probing of moral and philosophical issues, this powerful and often-performed Greek drama reveals the grim fate that befalls the children of Oedipus. Footnotes. 64pp. 5³⁄₁₆ x 8 ¼. 0-486-27804-2

ART DECO DECORATIVE PATTERNS IN FULL COLOR, Christian Stoll. Reprinted from a rare 1910 portfolio, 160 sensuous and exotic images depict a breathtaking array of florals, geometrics, and abstracts — all elegant in their stark simplicity. 64pp. 8⅜ x 11. 0-486-44862-2

THE ARTHUR RACKHAM TREASURY: 86 Full-Color Illustrations, Arthur Rackham. Selected and Edited by Jeff A. Menges. A stunning treasury of 86 full-page plates span the famed English artist's career, from *Rip Van Winkle* (1905) to masterworks such as *Undine, A Midsummer Night's Dream,* and *Wind in the Willows* (1939). 96pp. 8⅜ x 11.
0-486-44685-9

THE AUTHENTIC GILBERT & SULLIVAN SONGBOOK, W. S. Gilbert and A. S. Sullivan. The most comprehensive collection available, this songbook includes selections from every one of Gilbert and Sullivan's light operas. Ninety-two numbers are presented uncut and unedited, and in their original keys. 410pp. 9 x 12.
0-486-23482-7

THE AWAKENING, Kate Chopin. First published in 1899, this controversial novel of a New Orleans wife's search for love outside a stifling marriage shocked readers. Today, it remains a first-rate narrative with superb characterization. New introductory Note. 128pp. 5³⁄₁₆ x 8¼. 0-486-27786-0

BASIC DRAWING, Louis Priscilla. Beginning with perspective, this commonsense manual progresses to the figure in movement, light and shade, anatomy, drapery, composition, trees and landscape, and outdoor sketching. Black-and-white illustrations throughout. 128pp. 8⅜ x 11. 0-486-45815-6

Browse over 9,000 books at www.doverpublications.com

THE BATTLES THAT CHANGED HISTORY, Fletcher Pratt. Historian profiles 16 crucial conflicts, ancient to modern, that changed the course of Western civilization. Gripping accounts of battles led by Alexander the Great, Joan of Arc, Ulysses S. Grant, other commanders. 27 maps. 352pp. 5⅜ x 8½. 0-486-41129-X

BEETHOVEN'S LETTERS, Ludwig van Beethoven. Edited by Dr. A. C. Kalischer. Features 457 letters to fellow musicians, friends, greats, patrons, and literary men. Reveals musical thoughts, quirks of personality, insights, and daily events. Includes 15 plates. 410pp. 5⅜ x 8½. 0-486-22769-3

BERNICE BOBS HER HAIR AND OTHER STORIES, F. Scott Fitzgerald. This brilliant anthology includes 6 of Fitzgerald's most popular stories: "The Diamond as Big as the Ritz," the title tale, "The Offshore Pirate," "The Ice Palace," "The Jelly Bean," and "May Day." 176pp. 5⅜ x 8½. 0-486-47049-0

BESLER'S BOOK OF FLOWERS AND PLANTS: 73 Full-Color Plates from Hortus Eystettensis, 1613, Basilius Besler. Here is a selection of magnificent plates from the *Hortus Eystettensis*, which vividly illustrated and identified the plants, flowers, and trees that thrived in the legendary German garden at Eichstätt. 80pp. 8⅜ x 11.
0-486-46005-3

THE BOOK OF KELLS, Edited by Blanche Cirker. Painstakingly reproduced from a rare facsimile edition, this volume contains full-page decorations, portraits, illustrations, plus a sampling of textual leaves with exquisite calligraphy and ornamentation. 32 full-color illustrations. 32pp. 9⅜ x 12¼. 0-486-24345-1

THE BOOK OF THE CROSSBOW: With an Additional Section on Catapults and Other Siege Engines, Ralph Payne-Gallwey. Fascinating study traces history and use of crossbow as military and sporting weapon, from Middle Ages to modern times. Also covers related weapons: balistas, catapults, Turkish bows, more. Over 240 illustrations. 400pp. 7¼ x 10⅛. 0-486-28720-3

THE BUNGALOW BOOK: Floor Plans and Photos of 112 Houses, 1910, Henry L. Wilson. Here are 112 of the most popular and economic blueprints of the early 20th century — plus an illustration or photograph of each completed house. A wonderful time capsule that still offers a wealth of valuable insights. 160pp. 8⅜ x 11.
0-486-45104-6

THE CALL OF THE WILD, Jack London. A classic novel of adventure, drawn from London's own experiences as a Klondike adventurer, relating the story of a heroic dog caught in the brutal life of the Alaska Gold Rush. Note. 64pp. 5³⁄₁₆ x 8¼.
0-486-26472-6

CANDIDE, Voltaire. Edited by Francois-Marie Arouet. One of the world's great satires since its first publication in 1759. Witty, caustic skewering of romance, science, philosophy, religion, government — nearly all human ideals and institutions. 112pp. 5³⁄₁₆ x 8¼. 0-486-26689-3

CELEBRATED IN THEIR TIME: Photographic Portraits from the George Grantham Bain Collection, Edited by Amy Pastan. With an Introduction by Michael Carlebach. Remarkable portrait gallery features 112 rare images of Albert Einstein, Charlie Chaplin, the Wright Brothers, Henry Ford, and other luminaries from the worlds of politics, art, entertainment, and industry. 128pp. 8⅜ x 11. 0-486-46754-6

CHARIOTS FOR APOLLO: The NASA History of Manned Lunar Spacecraft to 1969, Courtney G. Brooks, James M. Grimwood, and Loyd S. Swenson, Jr. This illustrated history by a trio of experts is the definitive reference on the Apollo spacecraft and lunar modules. It traces the vehicles' design, development, and operation in space. More than 100 photographs and illustrations. 576pp. 6¾ x 9¼. 0-486-46756-2

Browse over 9,000 books at www.doverpublications.com

A CHRISTMAS CAROL, Charles Dickens. This engrossing tale relates Ebenezer Scrooge's ghostly journeys through Christmases past, present, and future and his ultimate transformation from a harsh and grasping old miser to a charitable and compassionate human being. 80pp. 5³⁄₁₆ x 8¼. 0-486-26865-9

COMMON SENSE, Thomas Paine. First published in January of 1776, this highly influential landmark document clearly and persuasively argued for American separation from Great Britain and paved the way for the Declaration of Independence. 64pp. 5³⁄₁₆ x 8¼. 0-486-29602-4

THE COMPLETE SHORT STORIES OF OSCAR WILDE, Oscar Wilde. Complete texts of "The Happy Prince and Other Tales," "A House of Pomegranates," "Lord Arthur Savile's Crime and Other Stories," "Poems in Prose," and "The Portrait of Mr. W. H." 208pp. 5³⁄₁₆ x 8¼. 0-486-45216-6

COMPLETE SONNETS, William Shakespeare. Over 150 exquisite poems deal with love, friendship, the tyranny of time, beauty's evanescence, death, and other themes in language of remarkable power, precision, and beauty. Glossary of archaic terms. 80pp. 5³⁄₁₆ x 8¼. 0-486-26686-9

THE COUNT OF MONTE CRISTO: Abridged Edition, Alexandre Dumas. Falsely accused of treason, Edmond Dantès is imprisoned in the bleak Chateau d'If. After a hair-raising escape, he launches an elaborate plot to extract a bitter revenge against those who betrayed him. 448pp. 5³⁄₁₆ x 8¼. 0-486-45643-9

CRAFTSMAN BUNGALOWS: Designs from the Pacific Northwest, Yoho & Merritt. This reprint of a rare catalog, showcasing the charming simplicity and cozy style of Craftsman bungalows, is filled with photos of completed homes, plus floor plans and estimated costs. An indispensable resource for architects, historians, and illustrators. 112pp. 10 x 7. 0-486-46875-5

CRAFTSMAN BUNGALOWS: 59 Homes from "The Craftsman," Edited by Gustav Stickley. Best and most attractive designs from Arts and Crafts Movement publication — 1903–1916 — includes sketches, photographs of homes, floor plans, descriptive text. 128pp. 8¼ x 11. 0-486-25829-7

CRIME AND PUNISHMENT, Fyodor Dostoyevsky. Translated by Constance Garnett. Supreme masterpiece tells the story of Raskolnikov, a student tormented by his own thoughts after he murders an old woman. Overwhelmed by guilt and terror, he confesses and goes to prison. 480pp. 5³⁄₁₆ x 8¼. 0-486-41587-2

THE DECLARATION OF INDEPENDENCE AND OTHER GREAT DOCUMENTS OF AMERICAN HISTORY: 1775-1865, Edited by John Grafton. Thirteen compelling and influential documents: Henry's "Give Me Liberty or Give Me Death," Declaration of Independence, The Constitution, Washington's First Inaugural Address, The Monroe Doctrine, The Emancipation Proclamation, Gettysburg Address, more. 64pp. 5³⁄₁₆ x 8¼. 0-486-41124-9

THE DESERT AND THE SOWN: Travels in Palestine and Syria, Gertrude Bell. "The female Lawrence of Arabia," Gertrude Bell wrote captivating, perceptive accounts of her travels in the Middle East. This intriguing narrative, accompanied by 160 photos, traces her 1905 sojourn in Lebanon, Syria, and Palestine. 368pp. 5⅜ x 8½.
 0-486-46876-3

A DOLL'S HOUSE, Henrik Ibsen. Ibsen's best-known play displays his genius for realistic prose drama. An expression of women's rights, the play climaxes when the central character, Nora, rejects a smothering marriage and life in "a doll's house." 80pp. 5³⁄₁₆ x 8¼. 0-486-27062-9

Browse over 9,000 books at www.doverpublications.com

DOOMED SHIPS: Great Ocean Liner Disasters, William H. Miller, Jr. Nearly 200 photographs, many from private collections, highlight tales of some of the vessels whose pleasure cruises ended in catastrophe: the *Morro Castle, Normandie, Andrea Doria, Europa,* and many others. 128pp. 8⅞ x 11¾. 0-486-45366-9

THE DORÉ BIBLE ILLUSTRATIONS, Gustave Doré. Detailed plates from the Bible: the Creation scenes, Adam and Eve, horrifying visions of the Flood, the battle sequences with their monumental crowds, depictions of the life of Jesus, 241 plates in all. 241pp. 9 x 12. 0-486-23004-X

DRAWING DRAPERY FROM HEAD TO TOE, Cliff Young. Expert guidance on how to draw shirts, pants, skirts, gloves, hats, and coats on the human figure, including folds in relation to the body, pull and crush, action folds, creases, more. Over 200 drawings. 48pp. 8¼ x 11. 0-486-45591-2

DUBLINERS, James Joyce. A fine and accessible introduction to the work of one of the 20th century's most influential writers, this collection features 15 tales, including a masterpiece of the short-story genre, "The Dead." 160pp. 5³⁄₁₆ x 8¼. 0-486-26870-5

EASY-TO-MAKE POP-UPS, Joan Irvine. Illustrated by Barbara Reid. Dozens of wonderful ideas for three-dimensional paper fun — from holiday greeting cards with moving parts to a pop-up menagerie. Easy-to-follow, illustrated instructions for more than 30 projects. 299 black-and-white illustrations. 96pp. 8⅜ x 11. 0-486-44622-0

EASY-TO-MAKE STORYBOOK DOLLS: A "Novel" Approach to Cloth Dollmaking, Sherralyn St. Clair. Favorite fictional characters come alive in this unique beginner's dollmaking guide. Includes patterns for Pollyanna, Dorothy from *The Wonderful Wizard of Oz*, Mary of *The Secret Garden*, plus easy-to-follow instructions, 263 black-and-white illustrations, and an 8-page color insert. 112pp. 8¼ x 11. 0-486-47360-0

EINSTEIN'S ESSAYS IN SCIENCE, Albert Einstein. Speeches and essays in accessible, everyday language profile influential physicists such as Niels Bohr and Isaac Newton. They also explore areas of physics to which the author made major contributions. 128pp. 5 x 8. 0-486-47011-3

EL DORADO: Further Adventures of the Scarlet Pimpernel, Baroness Orczy. A popular sequel to *The Scarlet Pimpernel*, this suspenseful story recounts the Pimpernel's attempts to rescue the Dauphin from imprisonment during the French Revolution. An irresistible blend of intrigue, period detail, and vibrant characterizations. 352pp. 5³⁄₁₆ x 8¼. 0-486-44026-5

ELEGANT SMALL HOMES OF THE TWENTIES: 99 Designs from a Competition, Chicago Tribune. Nearly 100 designs for five- and six-room houses feature New England and Southern colonials, Normandy cottages, stately Italianate dwellings, and other fascinating snapshots of American domestic architecture of the 1920s. 112pp. 9 x 12. 0-486-46910-7

THE ELEMENTS OF STYLE: The Original Edition, William Strunk, Jr. This is the book that generations of writers have relied upon for timeless advice on grammar, diction, syntax, and other essentials. In concise terms, it identifies the principal requirements of proper style and common errors. 64pp. 5⅜ x 8½. 0-486-44798-7

THE ELUSIVE PIMPERNEL, Baroness Orczy. Robespierre's revolutionaries find their wicked schemes thwarted by the heroic Pimpernel — Sir Percival Blakeney. In this thrilling sequel, Chauvelin devises a plot to eliminate the Pimpernel and his wife. 272pp. 5³⁄₁₆ x 8¼. 0-486-45464-9

Browse over 9,000 books at www.doverpublications.com